IMAGES
of America

TRURO

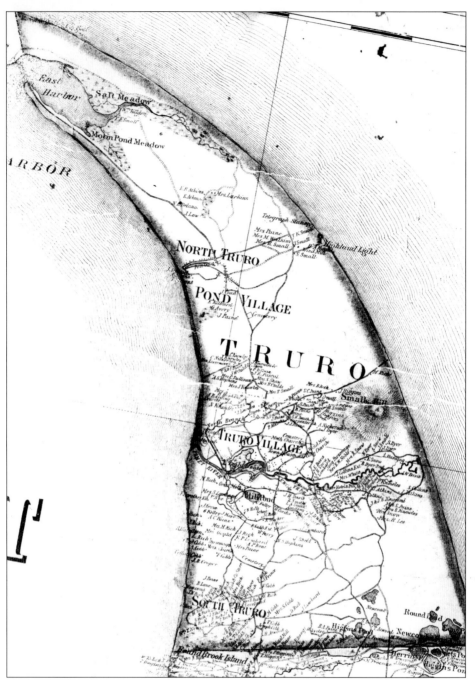

Located near the tip of Cape Cod, Truro is bordered by Provincetown to the north, Wellfleet to the south, the Atlantic Ocean to the east, and Cape Cod Bay to the west. Henry David Thoreau, in his classic work *Cape Cod,* referred to the location of this small and narrow land as the "wrist" of the Cape. Truro is about 21 square miles in area and, in some places, less than a half mile wide. At the time this 1858 map was made, Truro was divided into distinct villages. Pamet Harbor (near Truro Village) and East Harbor (near the Provincetown line) were still active fishing ports. (Courtesy Truro Historical Museum.)

IMAGES
of America
TRURO

Susan W. Brennan
and Diana Worthington

ARCADIA

First printed in 2002.

Published by Arcadia Publishing,
an imprint of Tempus Publishing, Inc.
2A Cumberland Street
Charleston, SC 29401

Printed in Great Britain.

Library of Congress Catalog Card Number: 2001096130

For all general information contact Arcadia Publishing at:
Telephone 843-853-2070
Fax 843-853-0044
E-Mail sales@arcadiapublishing.com

For customer service and orders:
Toll-Free 1-888-313-2665

Visit us on the internet at http://www.arcadiapublishing.com

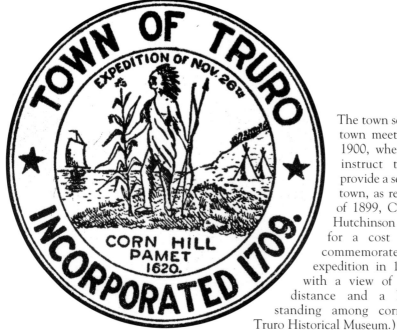

The town seal was adopted at a town meeting on February 5, 1900, when it was voted "to instruct the Selectman to provide a seal for the use of the town, as required by the Acts of 1899, Chapter 256." H.W. Hutchinson provided the seal for a cost of $3. The seal commemorates the Pilgrim expedition in 1620 at Corn Hill, with a view of their ship in the distance and a Native American standing among cornfields. (Courtesy Truro Historical Museum.)

CONTENTS

ACKNOWLEDGMENTS

We gratefully acknowledge the staff and board members of the Truro Historical Museum and their gracious access to the museum collection. In addition, we would like to thank the many people who opened their albums and memories to us. We are sorry that all of the photographs could not be included. We would also like to thank Hope Morrill (curator at the Cape Cod National Park Service), Betty Groom, Carlotta Zilliax, Teresa Izzo, Cynthia Slade (town clerk), and the descendants of Laura F. Silva, Thomas A. Kane, and Robert B. Worthington.

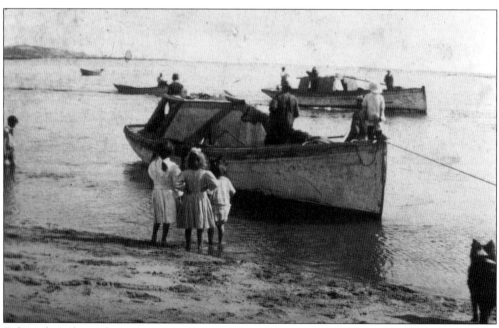

Fishing has always been an integral part of the Truro community. In this 1910 photograph, children wait to play on the trap boats after the catch has been unloaded.

INTRODUCTION

Truro, believed to have been named after Truro in Cornwall, England, was incorporated in 1709. It occupies a narrow peninsula of land on the outer Cape, next to Provincetown. Truro's history is rich and varied. From the Pilgrims learning to plant corn from the Pamet Indians on Corn Hill, to the fishing and whaling activities of the mid-1800s, and to the arts and recreation economy of today, the town has represented the best of ingenuity and determination.

In its early years, Truro was an important center of fishing, whaling, and agriculture. In 1850, there were more than 2,000 residents in Truro, the highest population the town has ever had. Lives revolved around church, eking a living from the land and sea, and the important business of running the town. Since its inception, Truro residents have proudly and vociferously decided its future at town meetings. The town also played an important role in naval navigation, warning, and search and rescue. Cape Cod Light, also known as Highland Light, was built in the late 1700s, shining its beacon miles out to sea and guiding ships through treacherous shoals. Search-and-rescue men (or surfmen, as they were known) rescued many hands from ships that foundered off Truro's shores.

Truro has undergone significant changes over the years. One of the most striking changes is the appearance of the land. Today, the hills are covered with scrub pine, locust, red and white oak trees, and other vegetation. For much of the 19th century, however, Truro's landscape was windswept and bare. Most of the timber was used for building homes and ships, and grazing animals either ate or trampled new seedlings. Truro's economic history began to change in the mid-1800s, when the silting of the harbor and the continued loss of lives at sea contributed to the decline of the fishing industry. Truro's population steadily decreased and, c. 1900, there were fewer than 600 residents in the town. Around that time, enterprising residents like Sheldon Ball, Lorenzo Baker, and Isaac Morton Small began to promote the beauty of Truro as a tourist attraction. When the railroad went through in 1873, Truro became more accessible to the rest of the world. The tourism industry steadily increased, and Truro has since been a vacation destination.

Truro is frequently mentioned as the only remaining town where one can see Cape Cod as it used to be. While this observation may be somewhat exaggerated, there is a good deal of truth to it. Truro is fortunate to have a large part of its land area designated as Cape Cod National Seashore. This protected land of woods, beaches, and rolling hills offers a unique glimpse of the uncluttered beauty enjoyed by many past generations. Today, there are numerous hiking and bike paths that take explorers over hills and "kettles" strewn with wildflowers, bayberry,

blueberry, huckleberry, and beach plums. There are also freshwater ponds sprinkled throughout Truro, as well as Pilgrim Lake, located at the Provincetown line. The beauty of these places and the undisturbed quality of this land give Truro a feel like no other town on Cape Cod.

Truro offers the best of both the ocean and the bay. To the east, Ballston and Longnook beaches are some of the most scenic on the Cape. To the west, the Pamet River harbor and the Ryder, Fisher, and Cold Storage beaches provide protected swimming and moorings for fishing and pleasure craft. The Pamet River stretches from Cape Cod Bay to within feet of the Atlantic Ocean. During a memorable storm in 1991, the ocean broke through the dunes at Ballston beach and, for a short time, North Truro and Provincetown were an island.

Over the years, Truro has aged gracefully and has managed to retain its rural appeal. Today there are approximately 1,600 year-round residents and many summer residents. There is an active and vibrant arts community, with institutions like the Truro Center for the Arts at Castle Hill. A new school, fire and police station, and library provide a modern infrastructure. The centers of town, such as they are, offer the basic amenities only. What visitors to Truro will find is a place of breathtaking natural beauty and a part of Cape Cod they will never forget.

One

PEOPLE AND PLACES

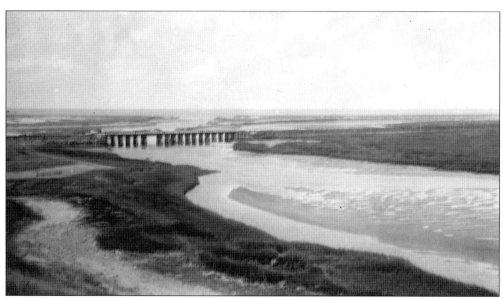

Looking west toward Cape Cod Bay, this 1910 image shows the peace and quiet of the Pamet River and Pamet Harbor. It is a far different scene than one would have found in the mid-1800s, when the harbor bustled with the activities of shipbuilders, sailmakers, warehouses, saltworks, blacksmiths, and chandleries, as the harbor was an active whaling and fishing center.

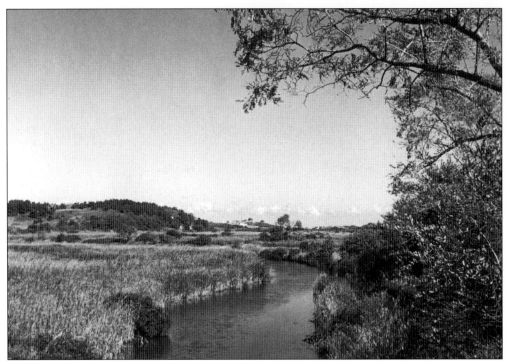

This view looks east up the Pamet River, toward Ballston Beach and the Atlantic Ocean. The Pamet River meanders east to west across the width of Truro. It is a tidal river formed by glaciers millions of years ago. Only a narrow strip of land separates the river from the ocean. (Courtesy Eloise Gardner.)

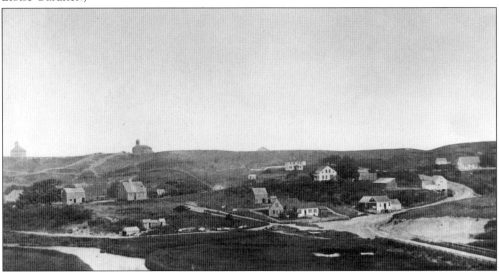

Settlers who needed wood to support everyday life deforested the hills of Truro in the 18th and 19th centuries. They built ships and houses, saltworks, and fencing. They heated their buildings with timber cut from the hills. In this c. 1900 photograph, the Congregational church and town hall are clearly visible on the hill to the left, and the Pamet River winds through the town center. The church was a beacon to ships at sea, serving as a landmark to guide vessels home. (Courtesy Truro Historical Museum.)

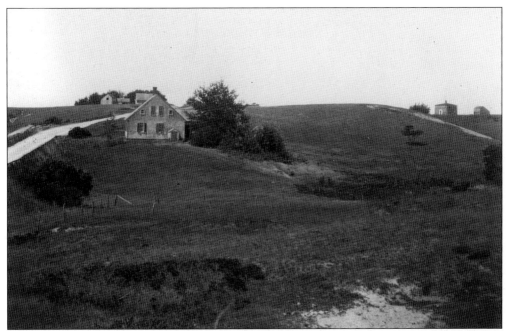

Depot Road in 1910 was a sparsely populated dirt road that led to the harbor. The house in the foreground, known as the Collins-Freeman house, is an example of a typical Cape Cod–style home. The entryway faces south to maximize exposure to the sun. It once had a small farm on its property and is thought to have been built by Michael Collins c. 1810. The house in the distance on the right is believed to have been built by Benjamin Collins (one of Michael Collins's four sons) in 1830, around the time of his marriage to Nebbal Thomas.

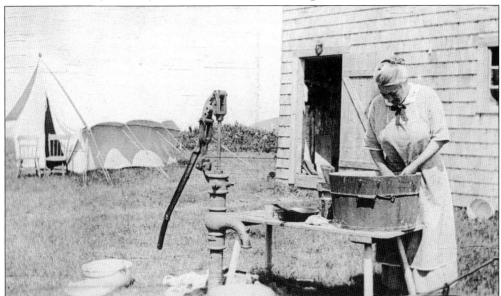

Life was filled with chores for the average housewife, as shown in this 1912 photograph taken outside the Benjamin Collins house. Water was pumped from the well and lugged to the house. Laundry was scrubbed by hand in wooden tubs. This family began coming to Truro in 1905 so their two-year-old daughter could recover from yellow fever.

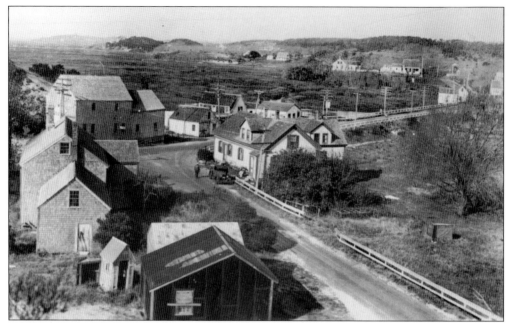

In this 1920s view, looking westward from the beginning of South Pamet Road, Truro center has a hotel, gas stations, a couple of stores, and a post office. Cape Cod Bay is visible in the distance, and the tidal marsh cuts a swath through the center of town. (Courtesy Truro Historical Museum.)

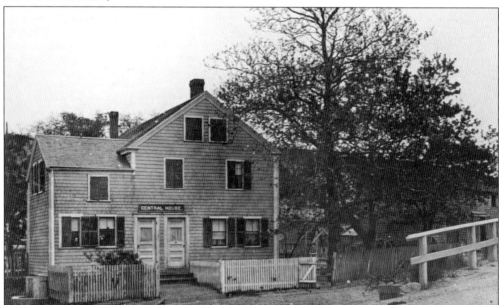

Ezra and Charlotte Hopkins owned the Central House (once known as Wilder's Hotel), located at the very tip of South Pamet Road. Like many Truro residents, they made their living by holding numerous jobs. The Central House let rooms and provided meals. Ezra held a contract from the government to run the daily mail from the train depot to town. He also owned a livery stable and occasionally drove the town hearse. The Central House burned to the ground in 1947. (Courtesy Truro Historical Museum.)

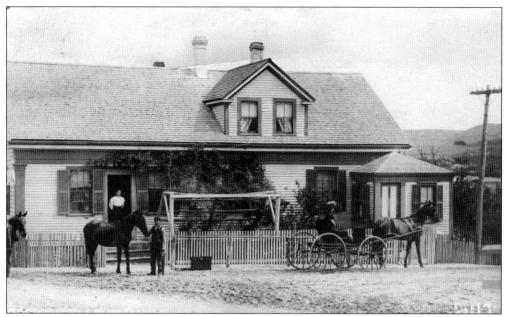

Just across the road from the Central House was the residence of Mary J. Snow and her family. In 1905, at the time of this photograph, one of the front rooms of Mary's house served as the post office, and she was postmaster, a position she held for 20 years. Mary also sold candy and other goods from the post office. There were two mail deliveries per day. This house was torn down, and a small park now occupies the land. (Courtesy Truro Historical Museum.)

Eben Paine, pictured in 1928, was a shopkeeper who had a general store in the center of Truro. He sold an assortment of meats, produce, canned goods, penny candy, tobacco, and kerosene. Eben (or an assistant) would deliver groceries from the back of his wagon to customers all over Truro. (Courtesy Dilys Staaterman.)

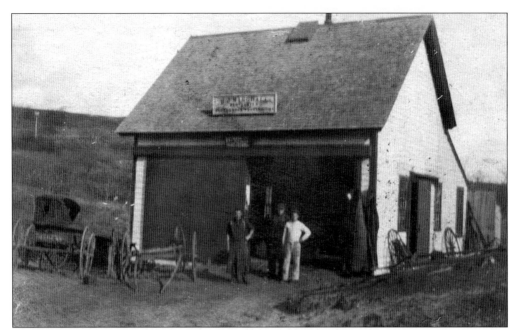

The blacksmith shop was originally a functioning stable until it was purchased c. 1900 and moved from Prince Valley Road to its current location just outside of Truro center. Manuel J. Marshall was the blacksmith until c. 1917, when the advent of the automobile caused his business to decline. Since then, the building has housed a garage and a fish market. It is now a popular restaurant. (Courtesy Truro Historical Museum.)

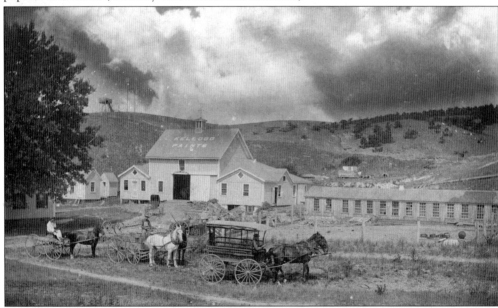

Charles W. Snow was a contractor, builder, entrepreneur, and businessman who served as the Truro superintendent of roads for many years. His letterhead from 1928 states that he is a dealer in "paints, oils, varnishes, hardware, lime, cement and drain pipe, plumbing, wood and coal." This c. 1893 photograph of his farm on Castle Road shows his advertising skills atop the barn. The barn is now part of the Truro Center for the Arts at Castle Hill. (Courtesy Isaiah Snow.)

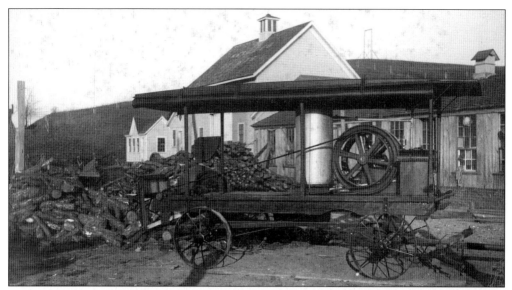

One aspect of Charles W. Snow's activities was the sale of wood to the public. In the late 1800s, he owned this wood-sawing machine. Wood was difficult to come by, as most of the hardwood had been used to build Truro during the 18th and early 19th centuries. (Courtesy Isaiah Snow.)

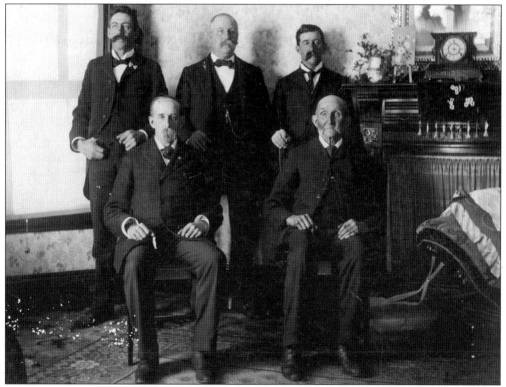

Pictured *c.* the 1880s are Charles W. Snow and his family. They are, from left to right, as follows: (front row) Isaiah Snow and Orlando Partridge Snow; (back row) Charles W. Snow, Ephraim Anthony Snow, and George Washington Snow. Brother John was not present. (Courtesy Isaiah Snow.)

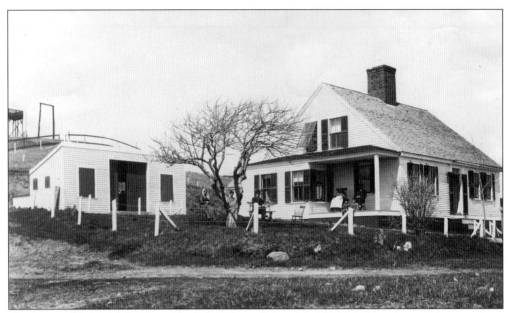

The Snow family can trace its lineage back to the earliest days of Truro. At one point, there were so many Snow family members living in one part of Truro that it was referred to as Snow Village. The Snow homestead, pictured here in 1888, was built in 1810. Only Snow family members have lived in it since that time. (Courtesy Isaiah Snow.)

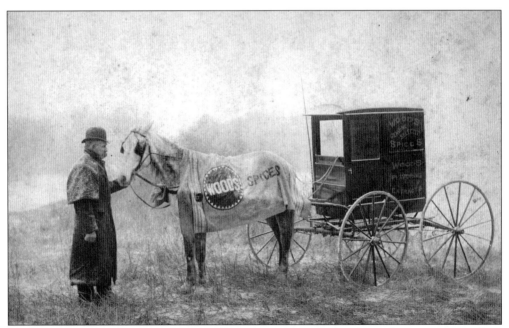

Isaiah Snow (born in 1842) traveled along the Cape with his horse-drawn wagon, selling Wood's teas, coffees, and spices. This photograph was taken near Cedar Swamp in Orleans. (Courtesy Isaiah Snow.)

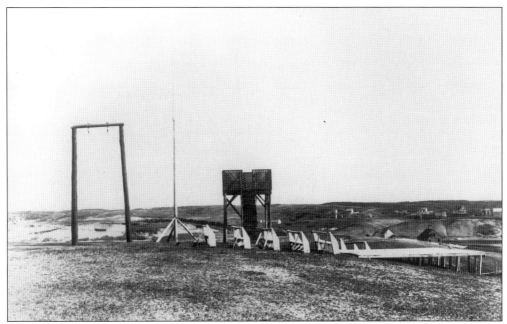

On the hill behind the Snow homestead was the Breezy Hill Methodist Campground. This outdoor recreational and religious meeting area had a wooden platform for speakers, benches for the audience, and a swing to entertain children. From the viewing stand in the middle, one could see for miles across the hills of Truro and to the sea. (Courtesy Truro Historical Museum.)

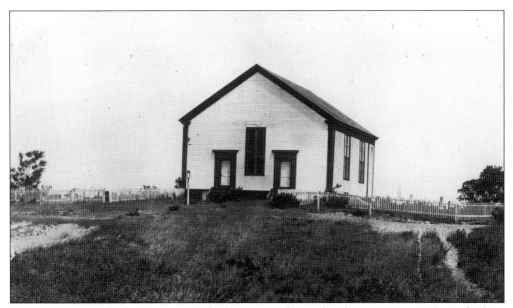

The simple square building was a Methodist meetinghouse for almost 100 years. It was built in 1826 to replace an earlier meetinghouse and served its congregation until the early part of the 20th century. In 1925, the building was purchased by Caleb Arnold Slade, who moved it, piece by piece, to nearby land that he owned. Slade, an artist, used it for his studio. (Courtesy Truro Historical Museum.)

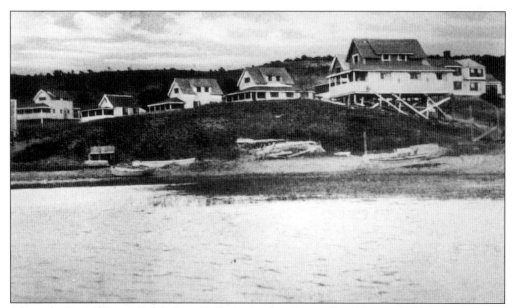

Along the Pamet River, Caleb Arnold Slade developed a small community of summer cottages that became known as Sladeville. Slade was best known as a portrait artist of well-known subjects from politics and the military. He supplemented his income with the rentals of his cottages. The cottages are, from left to right, Westoe, Normandia, Pameton, Castleway, Cheerio, and Edgehill. (Courtesy Truro Historical Museum.)

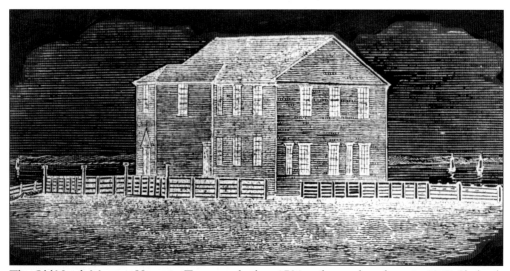

The Old North Meeting House in Truro was built c. 1721 and was taken down in 1840. Shebnah Rich, the 19th-century historian of Truro, referred to this as the "meeting house on the hill of storms." According to Rich, a meetinghouse is mentioned in town records dating from 1709, in the Act of Incorporation. This one was built per order of the town meeting of October 3, 1720. In 1721, the town voted that the pew room in the meetinghouse should "not to be sold less than thirty pounds, nor more than forty pounds." (Courtesy Truro Historical Museum.)

Rev. John Avery was the first minister to serve in Truro. His ministry commenced in 1710 and ended 44 years later, when he died on April 23, 1754. Revered by the townspeople, he was also a doctor, farmer, and blacksmith. His gravestone reads, "In this dark cavern, in this lonesome grave, Here lies the honest, pious, virtuous friend; Him, Kind Heav'n to us priest and doctor gave, As such he lived; as such we mourn his end." His descendant Jane Avery (born in 1801) is credited with creating this sampler, done in Kensington stitch, at age 13. (Courtesy Mildred Garran.)

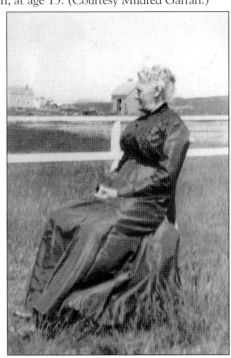

Amelia E. Hughes Rich was the granddaughter of Jane Avery and a descendant of John Avery. She lived in the Hughes homestead in North Truro. There are still descendants of John Avery in Truro today. (Courtesy Mildred Garran.)

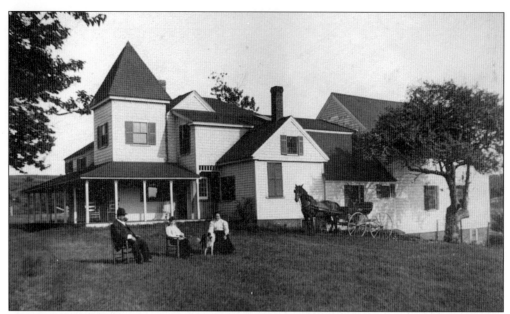

The Jonathan Collins house, at the corner of Collins and South Pamet Roads, was built as a one-and-a-half-story, Cape Cod–style house between 1820 and 1830. One owner transformed it *c.* 1900 into a Victorian-style house by adding a tower, porches, and bays, as pictured here. In the 1940s, it was transformed again, back to the original state. American artist and Truro resident Edward Hopper painted the house while it was a Victorian. (Courtesy Truro Historical Museum.)

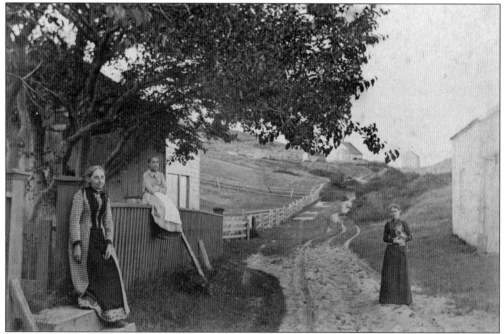

This *c.* 1890 photograph captures one of the first meetings between Priscilla Dyer (left) and her soon-to-be daughter-in-law, Elizabeth Brown (far right). Perched on the fence in the middle is Ethel Dyer, a young relative. Priscilla Dyer's brother-in-law, a sea captain, brought the white mulberry trees on the left from China. They are still standing today. (Courtesy Elizabeth Haskell.)

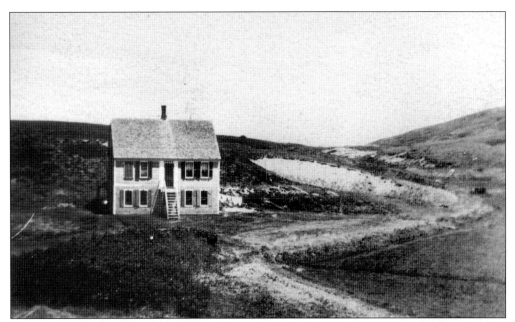

Truro had several productive cranberry bogs, including this one on North Pamet Road. The bog house, pictured here in 1912, was a two-level structure built adjacent to the bog. The first level stored equipment used in harvesting the cranberries, and the second level housed the manager of the bog and his family (or other workers). Truro's production of cranberries reached its peak in 1953. By the early 1960s, production had ceased. (Courtesy Elizabeth Haskell.)

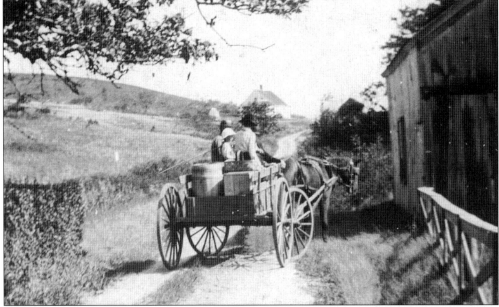

This 1925 photograph shows the fall gang going to pick cranberries at the bog on North Pamet Road. Once the cranberries were ripe, workers used wooden scoops to harvest the berries and placed them in wooden barrels. Cranberries were harvested from early September until the end of October. Men, women, and children were all involved in picking them. (Courtesy Elizabeth Haskell.)

Beach plums, or *Prunus maritima*, are another fruit that grows easily in the sandy, acidic soil in Truro. They are tart, round fruits that can be shades of yellow, red, and purple when ripe. The bushes have a white or pink flower, and the berries ripen from late August until early October. They are too tart to eat out of hand but are used in jams, jellies, and sauces. (Courtesy Dick Caouette.)

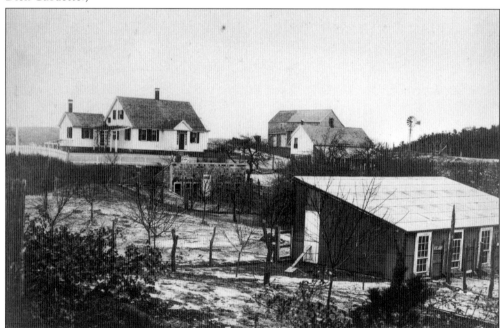

Edgewood Farm was owned by Manuel F. Corey. In addition to running his productive farm, he served in a variety of town offices, including town clerk, auditor, and on the board of library trustees. Edgewood Farm had an orchard and produced vegetables, poultry, and milk. (Courtesy Eleanor Meldahl.)

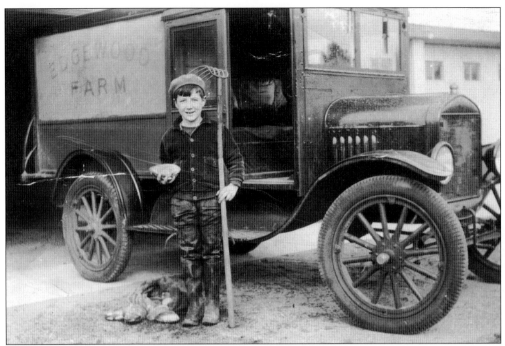

Francis "Brud" Mooney proudly shows off his sea clams at Edgewood Farm. The long-tined fork in his left hand is used to rake through the sand flats to unearth the sea clams. These tasty bivalves, also known as surf clams, are larger than the more commonly known quahog and littleneck clam and are used in chowders and sea clam pie. (Courtesy Dolores Rose.)

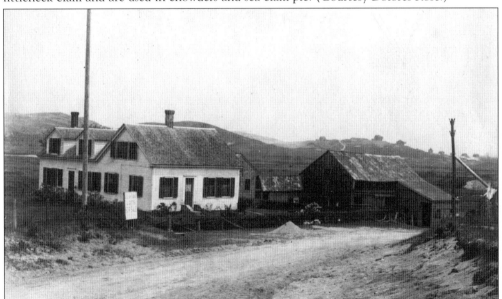

In 1847, Antone Rogers bought Oceanside Farm on South Pamet Road. His daughter married George Joseph, who took over the farm in 1899. Oceanside Farm had cows, horses, pigs, and chickens. It sold all kinds of fruits and vegetables, including strawberries, asparagus, carrots, peas, corn, and lettuce. George Joseph was a cobbler as well as a farmer. He sold milk and vegetables from his carriage as far away as Provincetown. (Courtesy Dolores Rose.)

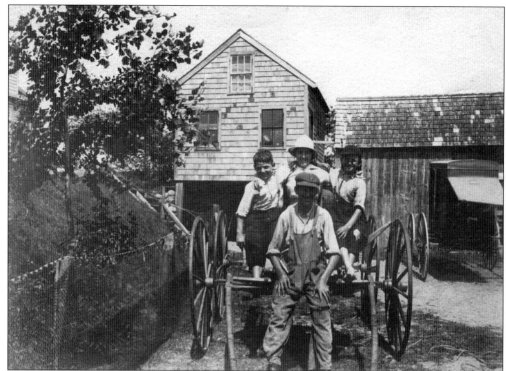

The barn at Oceanside Farm was on the north side of the road, as seen in this August 1913 photograph. The farm had a cranberry bog on the south side of the road. Arthur Joseph is in front of the wagon. Seated are Miss Crawley and two unidentified boys. (Courtesy Dolores Rose.)

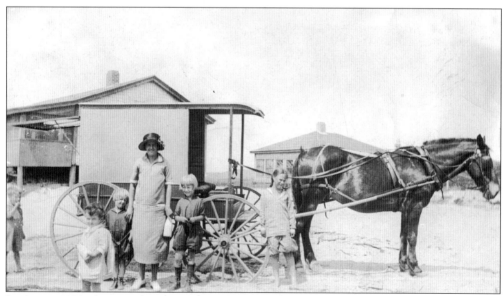

In this c. 1930 photograph, Annie B. Joseph is standing in front of the carriage belonging to Oceanside Farm. They are delivering food to the Ballston Beach summer colony. Oceanside supplied the colony with fresh vegetables, milk, and eggs. (Courtesy Dolores Rose.)

Ernest Hayes Small owned Highland Dairy in the early 1900s. In addition to growing vegetables, he raised cattle, pigs, and poultry. In 1935, Sumner Horton purchased the farm. (Courtesy Robert Horton.)

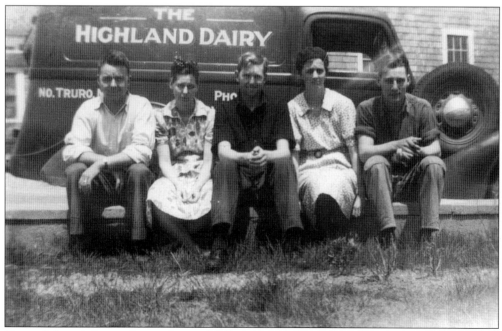

Pictured from left to right are Irving, Nellie, Sumner, Rachel, and James Horton. (Courtesy Robert Horton.)

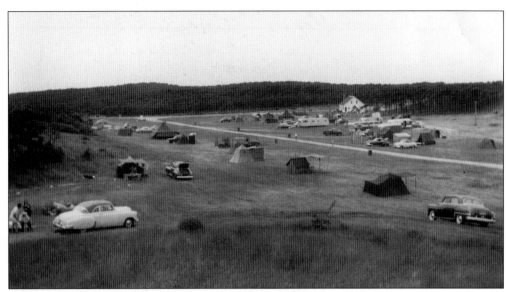

By the time of this 1950s photograph, the Highland Dairy had been transformed into Horton's Trailer Park, a successful recreational campground. (Courtesy Robert Horton.)

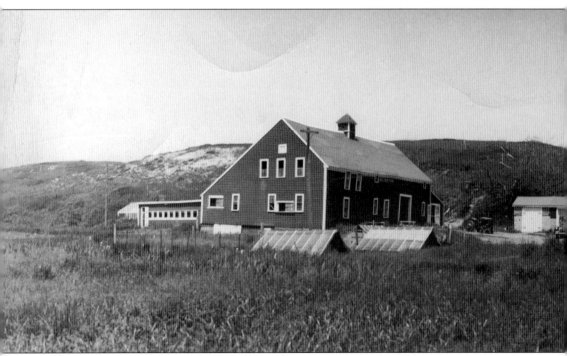

Hillside Farm is another example of a working farm in Truro. Owned by the Perry family, Hillside has been in operation since the 1800s. Originally a dairy farm, it changed to a poultry

Shown here in 1947 are three generations of the Perry family, owners and operators of Hillside Farm. They are, from left to right, Manuel Perry, Stephen Perry, and John Perry. (Courtesy Stephen Perry.)

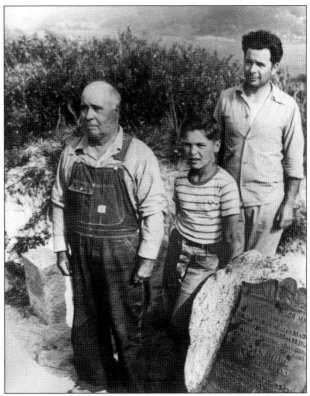

farm in the 1920s. The Perry family now owns and operates their farm stand and a complex of retail stores on Route 6. (Courtesy Donna Rowell.)

Shebnah Rich was a noted historian, genealogist, and author of *Truro, Cape Cod or Land Marks and Sea Marks* (published in 1883 by D. Lothrop and Company). The son of a mariner, he was born in Longnook in 1824. In addition to *Truro*, he was the author of *New England Mackerel Fisheries* and numerous articles. He died in 1907. (Courtesy Truro Historical Museum.)

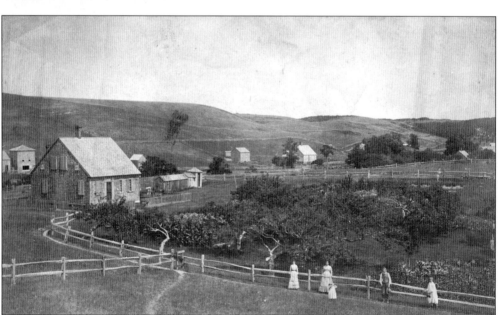

This *c.* 1890 photograph of a typical Truro house is noteworthy for the extensive fencing that surrounds the orchard and for the hills, which are devoid of any vegetation. The wood for the split-rail fence was in such short supply that lengths of it indicated the value of the orchard to the homeowner. (Courtesy Helen Menin.)

Zana B. Small was the first woman to own a registered motor vehicle in Truro. In this photograph, she proudly shows off her Model A. (Courtesy Edwina Wright.)

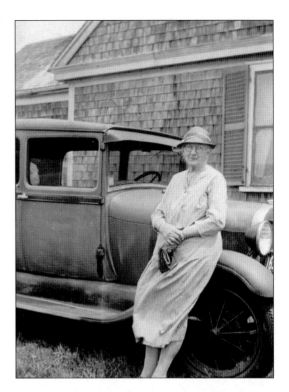

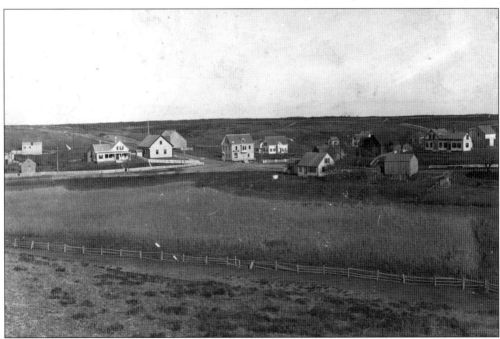

This view shows North Truro center before 1904. The house with the porch, facing the cornfield, was at one time the home of Edwin P. Worthen. Worthen was keeper of the Highland Life Saving Station for many years and was also the postmaster for North Truro. A cornfield is visible in the foreground. (Courtesy Truro Historical Museum.)

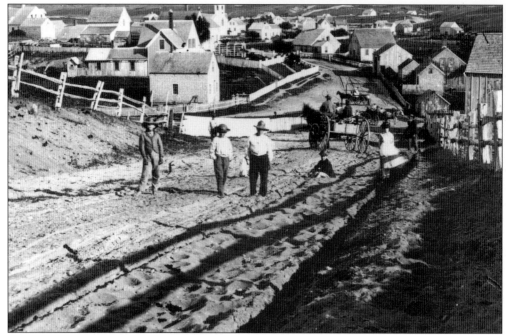

Horse and buggy is the mode of transportation in this c. 1890 photograph of County Road, in North Truro center. Children are playing in the dirt road just next to North Truro Primary Grammar School, which is on the right side of the road, obscured by a barn. The steeple of the Christian Union church is visible in the distance just to the left. (Courtesy Truro Historical Museum.)

This house is thought to have been built c. 1740 by John Hughes. According to family records, the wood used to construct the house came from ships that were wrecked off Highland Light. The bricks to build the oven came from Holland. (Courtesy Suzanne Jaxtimer.)

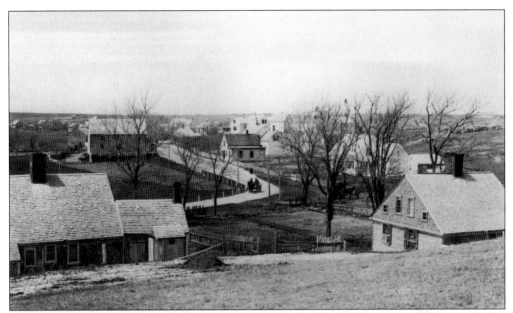

Taken from behind the Hughes house, this c. 1870 photograph shows the residence of John Grozier Thompson, just past the curve in the road on the right. Thompson operated a store from this location and also owned a grain and flour warehouse, as well as a livery stable, just across the road. He operated the store until his death in 1920. (Courtesy Suzanne Jaxtimer.)

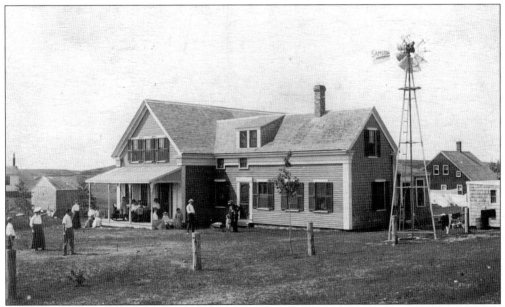

In the late 1800s, a widow by the name of Panthea Whitman rented rooms in her house as a means of augmenting income for herself and her numerous children. One of her daughters married Burton S. Hart, who built the Whitman House into a full-service inn. Guests were met at the North Truro railroad depot and ferried to the inn by horse and buggy. Owned and operated by the Rice family since the 1960s, the Whitman House is a popular restaurant today. (Courtesy Joel Grozier.)

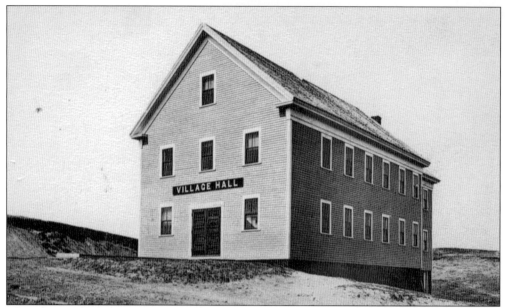

The village hall was originally a shirt factory in Provincetown. In the early 1900s, a group of residents formed the Village Hall Association. They purchased the building and moved it to North Truro in 1904 for a place to hold dances and social activities, such as whist parties, spelling bees, and plays. The building was converted into a firehouse in the 1950s by removing the second floor. (Courtesy Joel Grozier.)

John Wilson was a Truro resident and veteran of the Civil War. He enlisted in December 1863 and was a member of Company A, 58th Regiment, Massachusetts Volunteers. On July 30, 1864, he was captured by the Confederate army. Eventually released, Wilson wrote of his experiences in a manuscript entitled "Seven Months in a Rebel Prison." Wilson describes in detail the death of friends in prison and his feelings of despair and hunger as they were forced to eat rats to survive. (Courtesy Elizabeth Haskell.)

Betsy Snow Rich Grozier was born on February 18, 1843, and died in 1925. In 1861, she married John Paine Grozier, the Civil War veteran for whom Grozier Square in North Truro is named. He was born on December 19, 1841, and died in 1900. (Courtesy Lillian Grozier.)

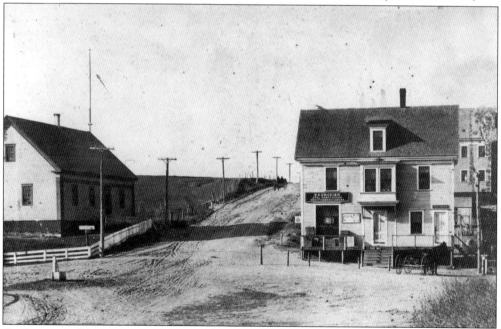

At the time of this *c.* 1900 photograph of Grozier Square, Betsy Grozier operated a store that sold dry goods and confectioneries on one side of the building and was a post office on the other side. The store was purchased by the Dutra family in 1919 and still operates as a grocery store. North Truro Primary Grammar School, which housed primary and elementary grades, was across the intersection. (Courtesy Lillian Grozier.)

Henry Upton "Uppie" Grozier was the Barnstable County Garden Club champion at age 15. From his 18,000-square-foot garden plot, he produced and sold 60 quarts of beans and 50 dozen ears of corn. He died at age 28 as the result of an accident at the train depot. (Courtesy Joel Grozier.)

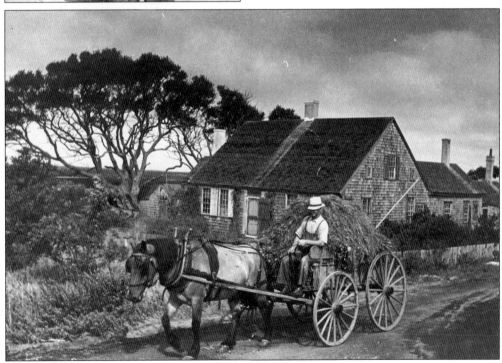

Tashmuit, one of the oldest houses in Truro, is believed to have been built *c.* 1797 by Isaac Small (1754–1816) near the grounds of Highland Light. A loose translation of the Native American word *tashmuit* is "place of many springs." This area contained some of the most fertile soil in Truro. In 1798, Tashmuit was the most heavily valued residence in Truro.

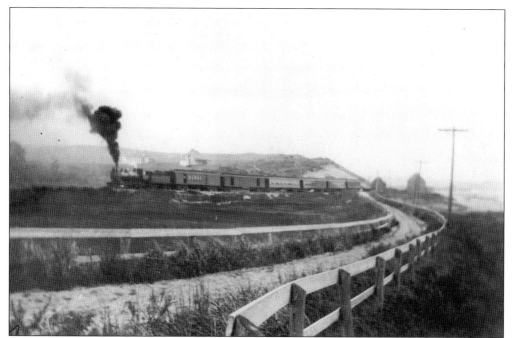

Railroad service was completed from Wellfleet through Truro to Provincetown in July 1873. Provincetown was 120 miles from Boston via railroad. As seen in this c. 1910 photograph of the train headed north toward Corn Hill, the railroad tracks were, in some places, very close to the shore. Before the completion of the railroad, tourism in Truro was limited due to its remote location, but it began to increase after the railroad was finished.

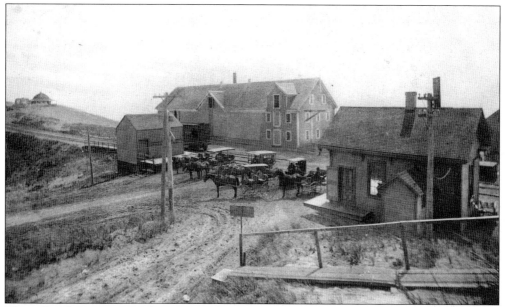

The railroad station in North Truro was located at the top of the hill and near the North Truro Cold Storage Company. Disembarking passengers were met by horse and buggy and were often ferried to nearby summer resorts. The mail was also delivered via train and distributed to the local post offices.

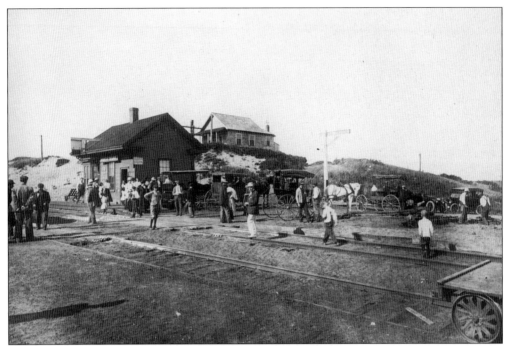

The North Truro railroad station, one of four stations in town, was a busy place c. 1912. Several companies were located near this station, including a fish-canning company, a candle-making company, and a fish-freezing plant. There were also hotels and summer colonies nearby. This station also had a Western Union telegraph office in it. Although horse and carriage was still the most common form of transportation, automobiles were beginning to appear.

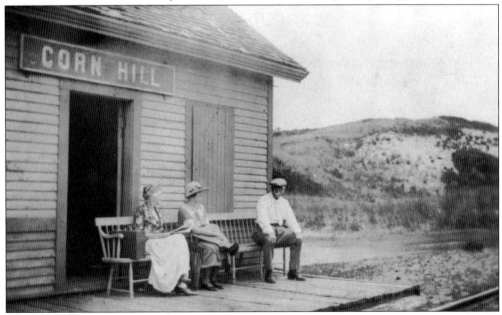

Three of the stations were attended, but the Corn Hill station was a flag stop. When passengers wanted the train to stop, they tripped the flag on the roof to notify the conductor. This station was a half mile north of the Truro station. (Courtesy Truro Historical Museum.)

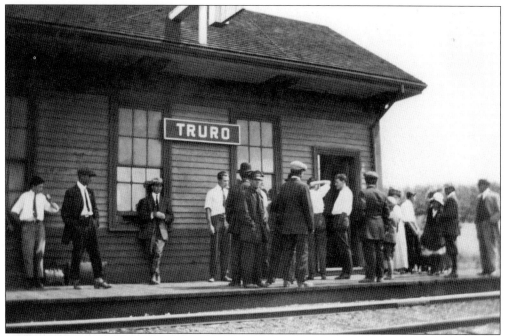

The Truro railroad station, pictured *c.* 1910, was at the end of Depot Road, on the Pamet River. Like the other stations, the depot was a simple structure with a ticket office, waiting rooms, and baggage rooms. There were usually two trains to Boston on a daily basis, and extra trains were run in the summertime for tourists.

Isaac Freeman was the second stationmaster for the railroad at the Truro station. George Hamilton was the first stationmaster. Isaac Freeman married Hamilton's daughter Almena and succeeded his father-in-law in the position. Almena was trained in telegraphy by her father and operated a small telegraph office in the station. (Courtesy Truro Historical Museum.)

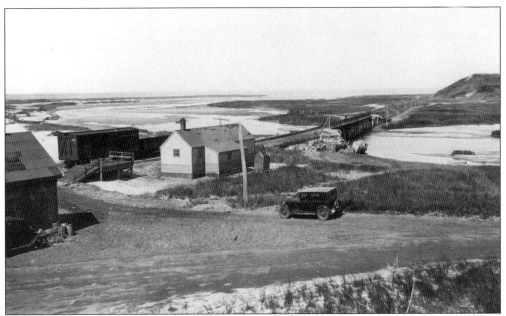

A simple wooden trestle bridge, shown here in the 1920s, carried the train over the Pamet River to Corn Hill. The river often overflowed its banks, and the bridge was subject to damage from the wind, storms, and tides. The Portland Storm of 1898, which caused a 1,000-foot washout, is only one of the great storms to have caused significant damage to the railway. (Courtesy Perry Anthony.)

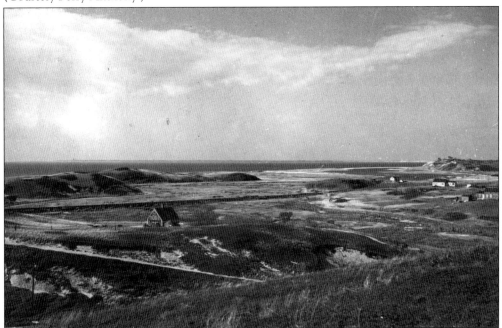

In this 1939 photograph, part of the mouth of the Pamet River lies north of its present location and near Corn Hill. The Great Hills area on the left is now covered with houses. The railroad tracks extending from South Truro to Corn Hill show the close proximity of the railroad stations to each other. (Courtesy Truro Historical Museum.)

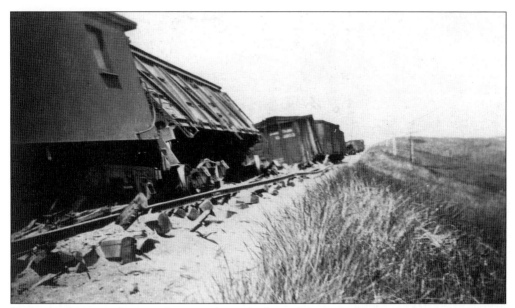

Train wrecks were always a threat in the early days of the railroad. It was not just a concern because of the possibility of injury to passengers but because so much of the economy depended on the railroad. It could take days to repair parts of the track. Meanwhile, products could not be shipped, mail could not be delivered, and everyday business was disrupted. (Courtesy Truro Historical Museum.)

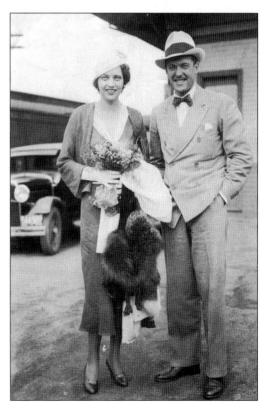

The railroad carried its share of celebrities to Truro, including actor Kenneth MacKenna (born Leo Mielziner Jr.) and his wife, actress Kay Francis, in 1932. MacKenna was visiting his family, who resided in Truro. (Courtesy Dolores Rose.)

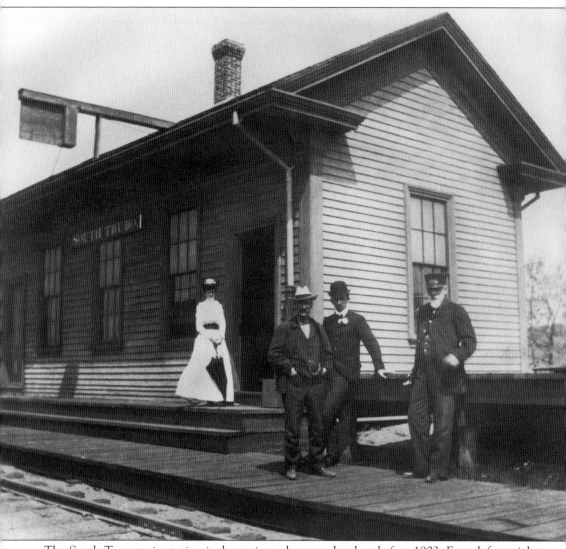

The South Truro train station is shown in a photograph taken before 1903. From left to right are Betsy Loveland, B. Gould, Charles Rich, and Solomon Rich (who served as stationmaster until 1909). (Courtesy Truro Historical Museum.)

Two

At Work and at Play

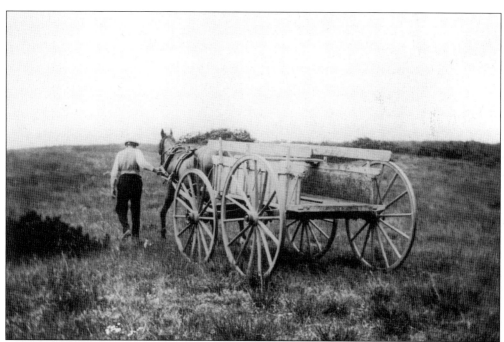

People were dependent on their horse and wagon to carry out the business of farming and transportation. Many families had several types of wagons. The fancy wagon was often covered and was used in bad weather and for transportation to church. The farm wagon was similar to the one pictured here c. 1910. The high slatted sides carried hay, produce, equipment, and whatever else the farmer needed.

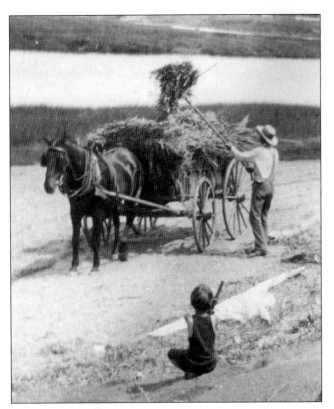

A farmer collects salt marsh hay along the banks of the Pamet River c. 1910. Salt marsh hay grows in the tidal marshes and along the banks of the river. It was used as feed for cattle and allowed farmers to avoid the cost of English hay.

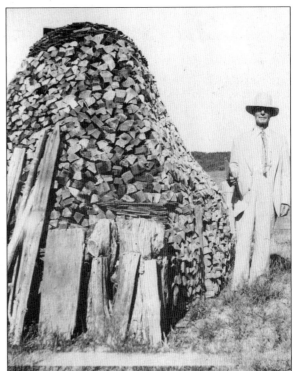

Alex Francis was very proud of his uniquely arranged woodpile. Late in life, Francis was the clam warden and the subject of a painting by artist Gerrit Beneker. (Courtesy Lillian Grozier.)

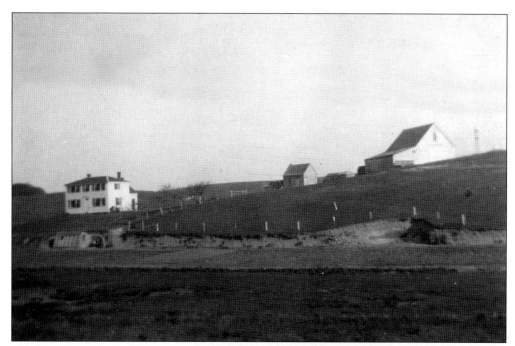

The Francis farm was aptly named Grand View because it faced west down Little Pamet valley, toward Corn Hill and Cape Cod Bay. Thirteen children were raised here, and the family took milk and vegetables by horse and wagon to sell in Provincetown. (Courtesy Charles Francis.)

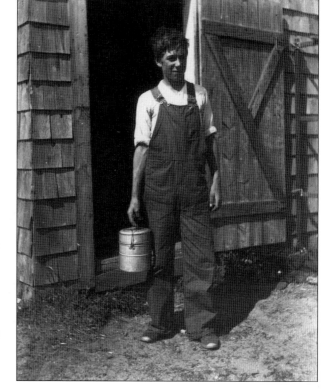

John Worthington started to come to Truro with his family c. 1900. He was intrigued by trap fishing and, from an early age, would rise and accompany the fishermen out to the weirs. The days started early, and Worthington packed his meal in a pail to take on the boat. At the time of this c. 1912 photograph, he already had several summers of experience on the trap boats.

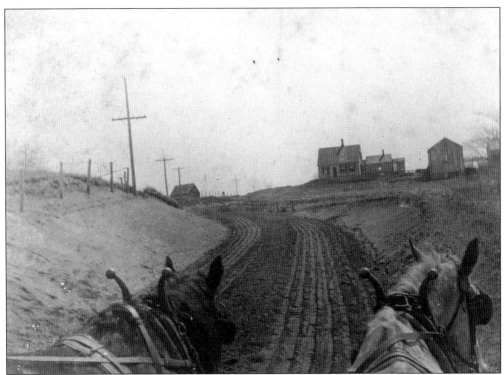

Construction and maintenance of roadways was an ongoing project in Truro. Prior to the laying of asphalt, roads were maintained by scraping, rolling, and grading. Charles W. Snow took this photograph from the roller while work was being done on Castle Road. (Courtesy Isaiah Snow.)

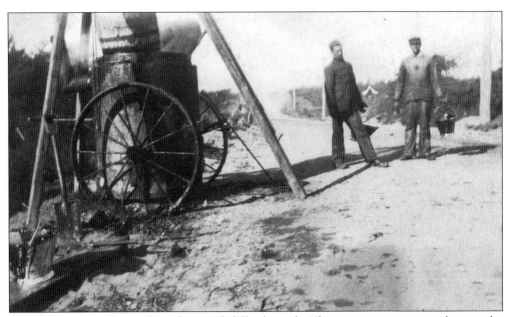

The tarring of roads was dirty, hot, and difficult work. The tar vat was set up close to the roadway, and tar was carried in buckets to lay on the road surface. (Courtesy Isaiah Snow.)

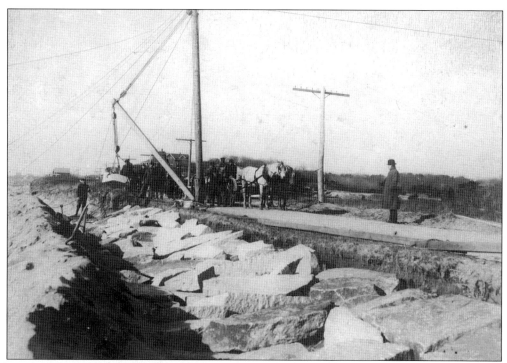

Workers are placing large pieces of granite alongside the road to bolster the embankment—a process called laying riprap. The granite arrived by ship from Boston and was moved to the work location by horse and wagon. (Courtesy Isaiah Snow.)

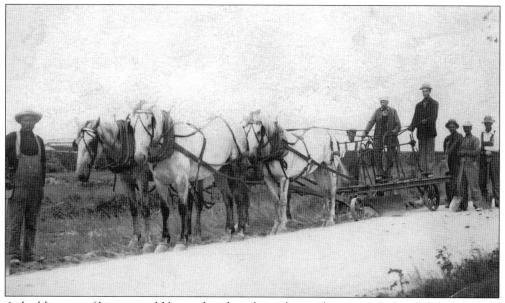

A double team of horses would be used to drag the wide metal scraper as it leveled the roadway. The rest of the road gang would follow behind the wagon and fill in holes by hand. (Courtesy Isaiah Snow.)

By the 1940s, the roads in the center of Truro were hard topped, but the rest of the center remained remarkably unchanged. A few stores had changed hands, and several gas stations had come and gone. The post office had changed locations from house to house around the square. Trees and vegetation had begun to return to the hills of Truro. (Courtesy Eloise Gardner.)

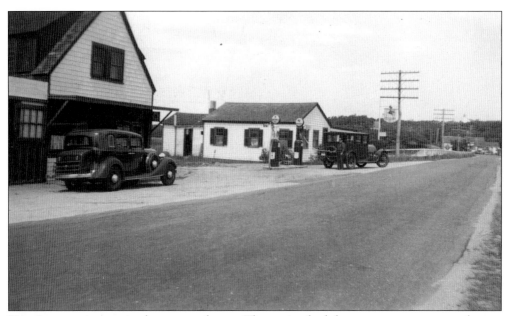

Tripp's gas station was in the center of town. The station had three pumps, a garage, and store. Next to it was a separate building that housed a pool hall. (Courtesy Eloise Gardner.)

Ervin C. Tripp was the owner of the gas station and pool hall in the 1930s. (Courtesy Eloise Gardner.)

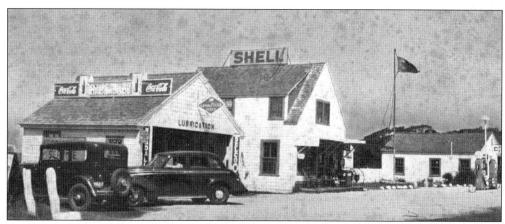

In the early 1940s, Horace "Pop" Snow (1882–1969) purchased the gas station complex. His son Horace "Snowie" Snow Jr. (1908–1971) took over the operation. Snowie's Shell Service, pictured here, was a place for gossip, car repair, Coca-Cola, and groceries. (Courtesy Isaiah Snow.)

From left to right are Horace Snow Jr., wife Dorothy, and son Kenneth *c.* 1943. (Courtesy Robert Grozier.)

This early-1940s photograph shows, from left to right, Tony Rule, Isaiah Snow, Dolores-ann Mooney, Horace Snow Jr., and John Worthington Jr. (Courtesy Truro Historical Museum.)

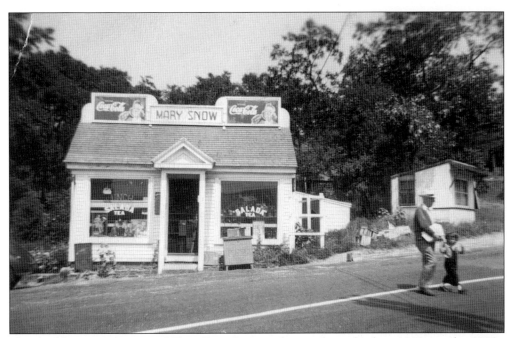

This building was the site of Eben Paine's general store from the late 1800s to the 1920s. Records found in the building indicate it had been used commercially since 1862. Over the years, it has been a grocery, apothecary, and sandwich shop. Mary Snow operated it as a little general store from the late 1930s. (Courtesy Walter Bingham.)

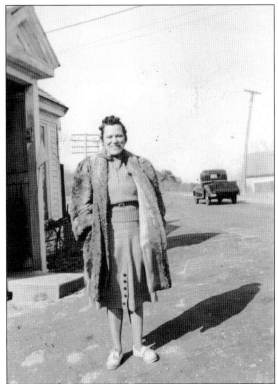

Mary Francis Snow, owner and operator of the general store, is pictured in April 1940. She paid the town a $2 fee for a victualer's license in 1939. In addition to being a store owner, she was a substitute teacher. (Courtesy Robert Grozier.)

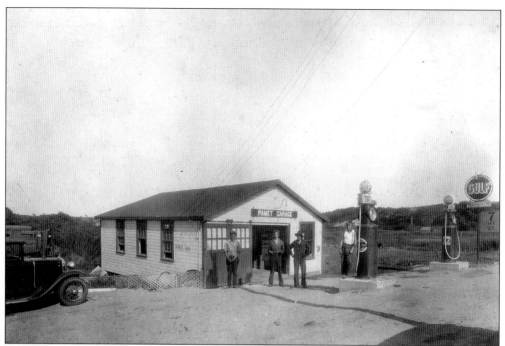

Buildings in the center of Truro have gone through several incarnations through the years. This Gulf gas station was located just down the road from Tripp's gas station, between the Pamet River and Cobb Library. Gas sold for 16¢ a gallon. It ceased functioning as a gas station and was transformed into another general store, owned by Mary Fratus. (Courtesy Ann Kelley.)

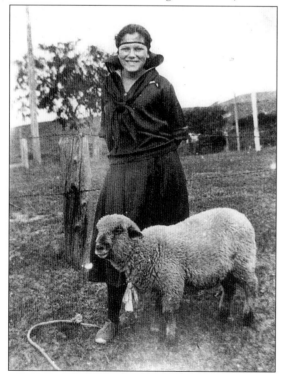

Mary Fratus was born, raised, and lived her entire life in Truro. She lived with her family on South Pamet Road and is shown here as a young girl with her sheep. (Courtesy Ann Kelley.)

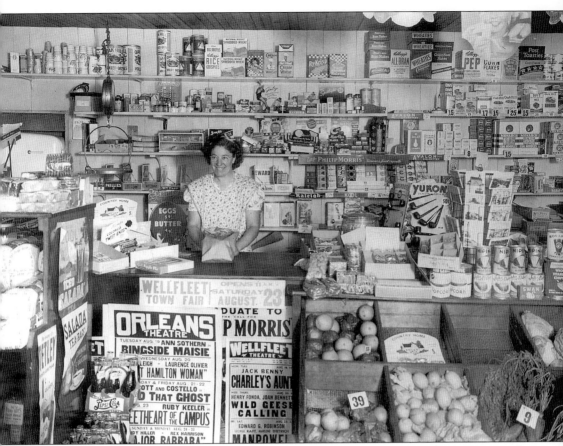

Mary Fratus is pictured in her store in 1940. She sold a variety of canned goods, groceries, and tobacco products and operated the store until her death in 1969. She was well known for her assortment of penny candy. (Courtesy Ann Kelley.)

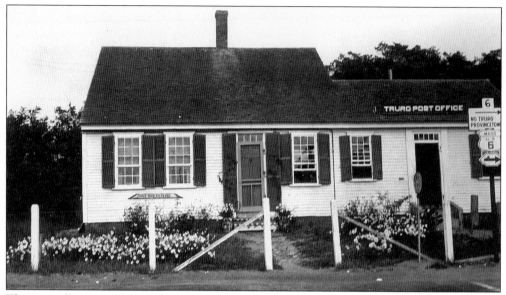

The post office moved from the house of Mary Snow, at the tip of South Pamet Road, to this house across from the library. It then moved to Wilder School, at the beginning of Depot Road. Mary E. Joseph was postmaster at this location and then moved with the post office to Wilder School. She was postmaster for 38 years. (Courtesy of Dolores Rose.)

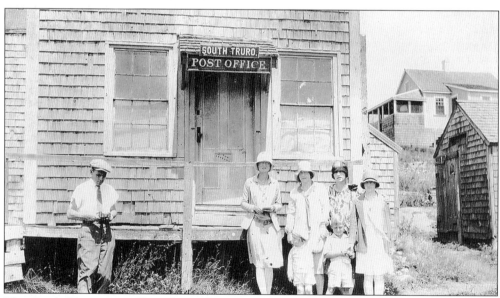

The South Truro post office, shown here c. 1930, was a gathering place for townspeople. Postmaster Burleigh Cobb would pick up the mail at the South Truro train station and bring it back in a sack to distribute. Today, Truro has two post offices—one in Truro center and the other in North Truro. (Courtesy Bill Cooper.)

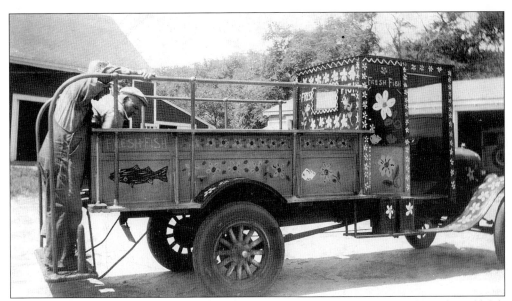

This enterprising fish dealer was a Provincetown resident named Frank Crawley, who sold fish from the back of his truck, door-to-door, and to markets along the Cape. He first drove a Ford Model T and then purchased an old fire truck to peddle his wares. All of his vehicles were distinguished by brightly painted decorations. He retired in 1950 when he was 84 years old. In this photograph, he is delivering fish to Hillside Farm in the early 1940s. (Courtesy Lucy Perry.)

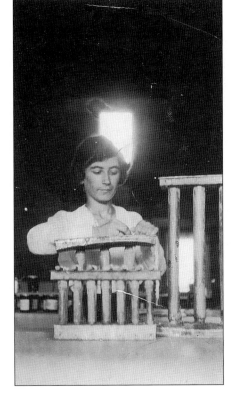

Laura Francis Silva started working at the Bayberry Candle Place in 1918. She rolled and twisted twine into wicks and hand-dipped candles. Bayberry wax was made by simmering bayberries for hours and then leaving the pot overnight. The next day, the wax, having risen to the top, was scraped off and used for candles. (Courtesy Truro Historical Museum.)

The bayberries gave the wax a beautiful shade of green. It took about 35 dips of the wick into the candle mold to make a regular-sized candle. An enclosure packed with the candles read, "A bayberry candle burned to the socket Brings luck to the house and gold to the pocket." (Courtesy Truro Historical Museum.)

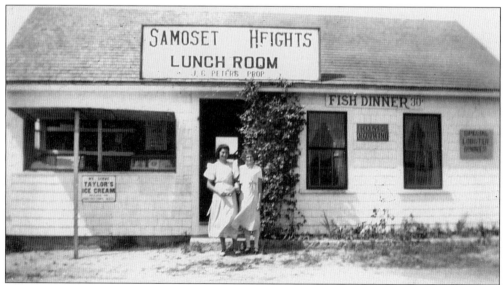

Ethel Jason Duarte (left) and Agnes Peters are shown c. the 1930s. The Samoset Heights Lunch Room was a roadside luncheonette at the top of Peter's Hill, across from the Old North Cemetery. A postcard advertising the lunch room suggests to "stop in for a good home cooked meal." Note the fish dinner for 30¢. The lunch room was owned by J.G. Peters. (Courtesy Joseph Peters.)

Tourism was an important business in Truro at the time of this July 1940 photograph. Many houses with extra rooms would rent to summer tourists. This one, called Highview, is advertising rooms and a bath. (Courtesy Robert Horton.)

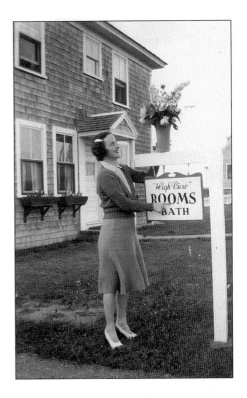

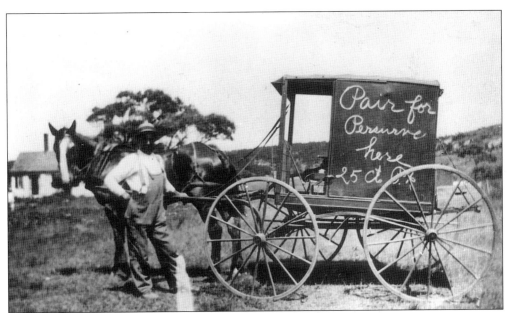

This man is an example of the industrious people who sold fruit and produce up and down the Cape from their horse-drawn carriages. "Pair for Perserve" is written on the side of the carriage. (Courtesy Truro Historical Museum.)

Henry Stevens Hutchings, born on January 6, 1838, wrote in his autobiography, "On the first day of his life, he did nothing but stay around and feel good." Hutchings lost his father at the age of seven and, at the age of nine, began to work for a local farmer. At age 13, he shipped out on the schooner *Tremont* and spent the next 12 years at sea on various vessels. In his thirties, he began farming for himself. He was also involved in the undertaking business for 30 years, until a change in state laws forced him to retire. At age 22, he married "a most estimable lady, Mary Jane Larkin, of East Harbor." He and his wife had four children. (Courtesy Truro Historical Museum.)

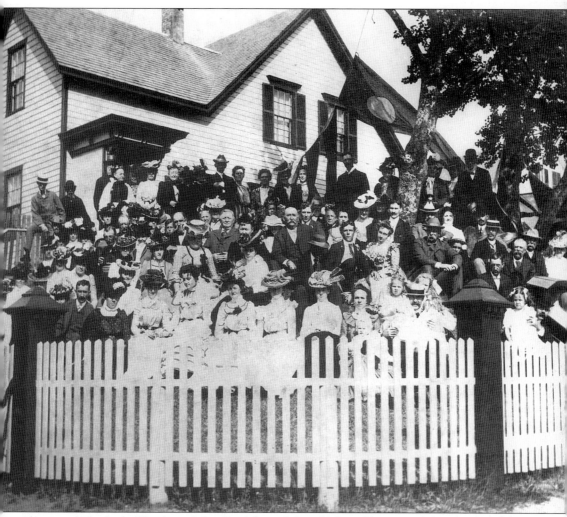

Abram and Elizabeth (Hutchings) Small celebrated their 50th wedding anniversary on June 17, 1902. It was an event so noteworthy that it was cited in a Boston newspaper. The couple had 15 children together, 10 of whom survived. All but one of their children joined them at the celebration. The article in the Boston newspaper described Abram as an 82-year-old man from "rugged New England stock." Elizabeth, 15 years his junior, was described as "robust." Abram apprenticed as a carpenter and became a master builder. He also owned a store. He met Elizabeth in 1852, and they were married that year. She served as the "custodian" for the library in North Truro. Prior to the building of libraries, books were kept in the custodian's home. (Courtesy Peter Vaughan.)

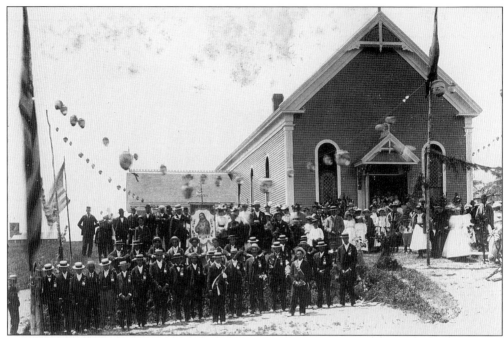

Located at the corner of Route 6A and Town Hall Road is the Sacred Heart Catholic church that was built in 1895. This photograph shows the dedication celebration in 1895. The building was originally a schoolhouse located on Old County Road. (Courtesy Dolores Rose.)

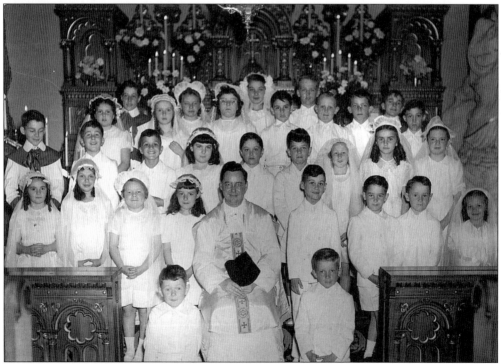

Children from Wellfleet and Truro are shown at the time of their first communion *c.* 1947. (Courtesy Toni Marsh.)

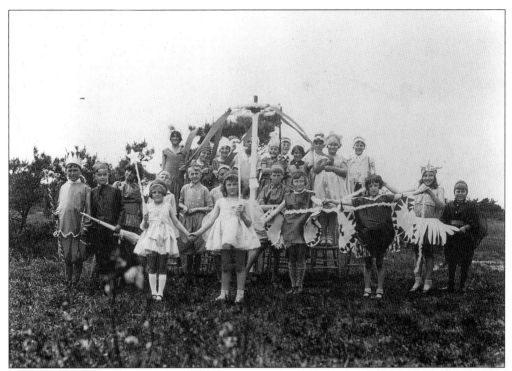

This May Day celebration was held on the west side of the town hall *c.* 1930. Today, participants still remember how much fun it was. In the front row are, from left to right, Cecilia Francis, Dolores-ann Mooney, Peggy Lucas, Thelma Rose, Marguerite Mooney, and Edgar Francis Jr. The others are unidentified. (Courtesy Elizabeth Haskell.)

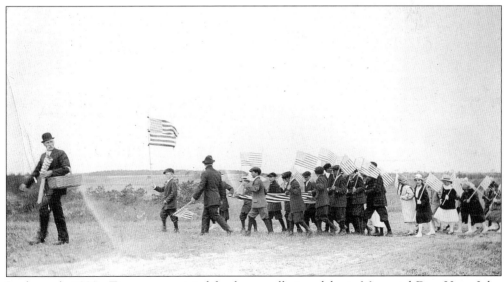

In the early 1900s, Truro appropriated funds annually to celebrate Memorial Day. Here, John B. Dyer leads a parade of children on Memorial Day. (Courtesy Elizabeth Haskell.)

Truro celebrated the 200th anniversary of the town's incorporation on July 16, 1909. The town clerk, John B. Dyer, gave the historical address, which concluded as follows: "Our record is in the past. As we review the generations gone, distance does lend enchantment to the view. As the native of the Cape grows older, the old associations grow dearer, and while mistakes and omissions are visible, yet we do love to say of Truro, and all that in it is, 'With all thy faults, I love thee still.'

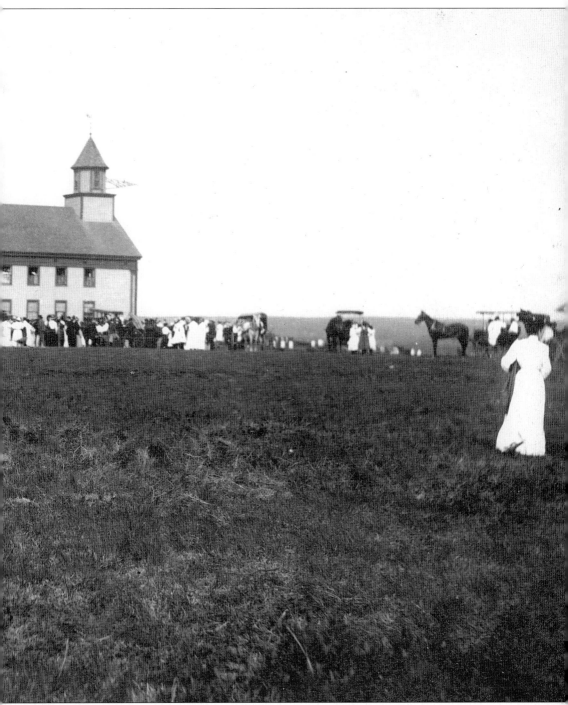

The memory of childhood and mother, the touch of the gentle hand whose shadow sometimes comes so near, are among the thoughts that wed us to the past. We shall do well to imitate the homely virtues of our fathers and their pious administrations, whose rule of conduct found a shaping in the principles of the Pilgrim fathers, for it always has been true and always will be true that 'Righteouness exalteth a nation.'" (Courtesy Isaiah Snow.)

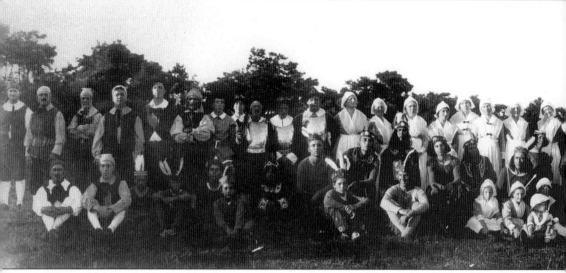

Truro celebrated the 300th anniversary of the Pilgrims' landing with a festive re-creation on August 20, 1920. The Tercentenary Pilgrim Pageant, as it was called, was advertised as "a carefully prepared, highly interesting, historically correct Drama." More than 3,000 customers paid 50¢ admission to see the play, which featured 150 Truro residents as Pilgrims, Native

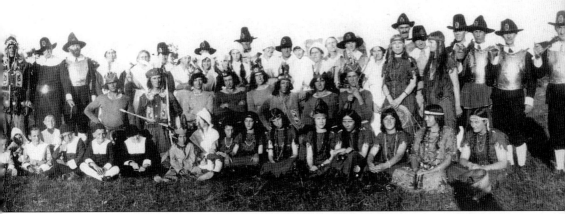

Americans, and such famous historical figures as Priscilla and John Alden. Almost $900 raised by the pageant was used to fund the building of Pilgrim Library in North Truro (below). Lillian Small donated the land, and David L. Snow constructed the building, which opened for business in 1924. The library did not receive electricity until 1948. (Courtesy Truro Historical Museum.)

Laurena Ryder was a librarian and the purchasing agent for school supplies. She cataloged the books in the library by the color of their book jackets. In 1899, the town appropriation for the library was $60. Ryder was paid $15 per year. (Courtesy Elizabeth Haskell.)

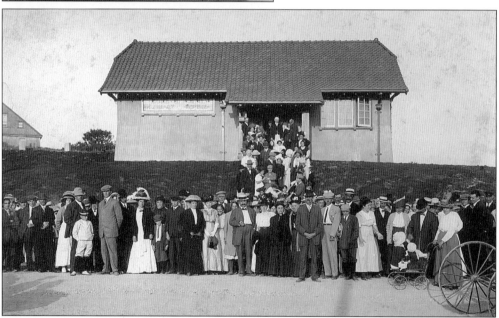

A large crowd turned out for the dedication of the Cobb Memorial Library on August 31, 1912. Elisha Wiley Cobb (born 1856) was a South Truro native who left to make his fortune in Boston. Hired as an assistant to a leather merchant, he quickly became partner with his employer and helped to make Beggs and Cobb into a successful tannery. Cobb purchased land in Truro center and built the library as a memorial to his parents. Two years after the dedication, there was another celebration when he donated a flag and flagpole to the library. (Courtesy Dolores Rose.)

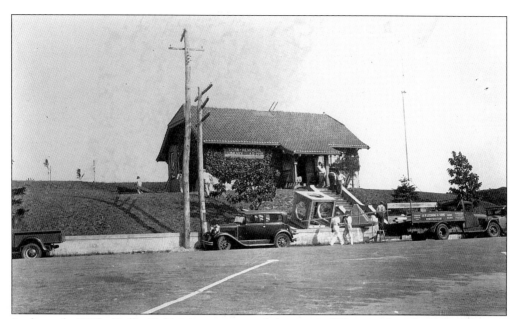

In the early 1930s, Nellie Cobb Magee presented the town of Truro with a clock for the top of Cobb Library, in memory of her father. The clock was set in a cupola perched on the roof. (Courtesy Dolores Rose.)

Joshua Hinkley Davis was the headmaster of Truro Academy, established in 1840 by a group of citizens who wished to educate their children near home. He operated the school until 1854, when a change in his health forced him to close the academy. Davis moved with his family to Somerville, where he became the first superintendent of the town's school system. He remained in that position until his retirement at age 74. (Courtesy Elizabeth Haskell.)

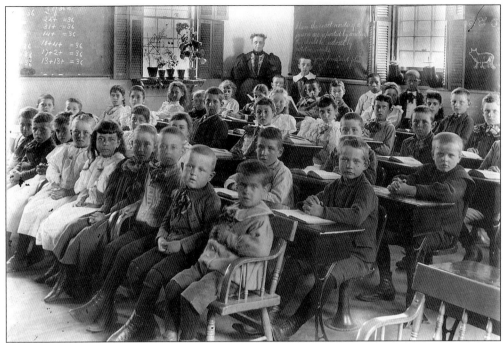

Betsey Holsbery, shown with her class in 1896, was a teacher in Truro for more than 50 years. In 1884, her salary was $332—quite an impressive sum for the times. She retired from teaching in 1907. After 1852, the town built seven schoolhouses spread throughout the area. In 1909, there were five community schools with 157 pupils among them.

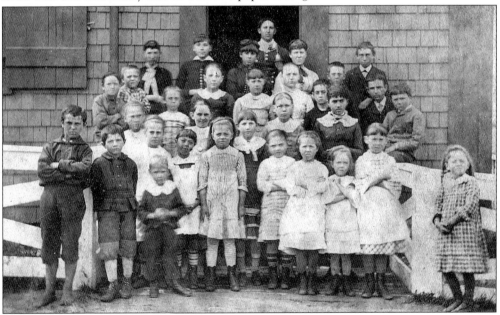

In 1869, Abbie Brown was a student in Betsey Holsbery's primary school. By 1883 (about the time of this photograph), she was a teacher in her own right, with a class of 32 students, in South Truro. In February 1884, she resigned her position due to health problems. She died in October 1884 at the age of 20. (Courtesy Barbara Baker.)

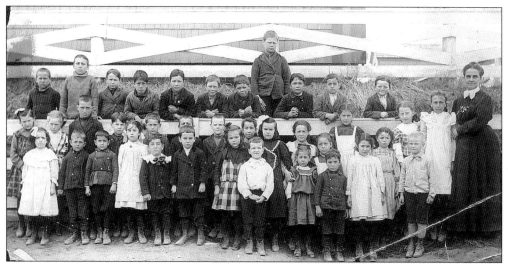

Wilder Primary School grades one through four are shown in 1908. From left to right are the following: (front row) Olive Silva, George B. Morris, Ernest Rogers, Mary Fratus, Frank E. Fisher, Anthony L. Marshall, Alma Rose, George Silva, Ernestine Rogers, John Fratus, Lucy Fratus, and Andrew Jordan; (middle row) Myra Jordan, Sarah L. Hatch, Joseph P. Morris, John Enos, Ernest M. Gray, John Silva, Charles Atwood, Maude Adams, Mildred Rose, Eva Gray, Mary Rogers, Ellen Rogers, Louise King, Annie M. Francis, Mary Silva, and teacher Mary E. Stocker; (back row) Antone Silva, William Silva, Joseph Francis, William (Perry) Marshall, Zenas Adams, William Adams, John Pimental, Henry Hanson, Joseph Fratus, Frank Rogers, and Francis J. Gray. (Courtesy Truro Historical Museum.)

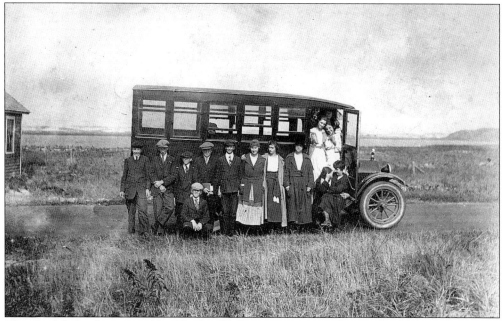

This Studebaker bus, owned by Charles W. Snow, was operated as a school bus at the time of this *c.* 1918 picture. Standing on the far left is Joseph Duarte. Standing sixth and seventh from the left are Louise Hatch and Anna Snow, respectively. The girl in the doorway on the left is Helen Snow. (Courtesy Isaiah Snow.)

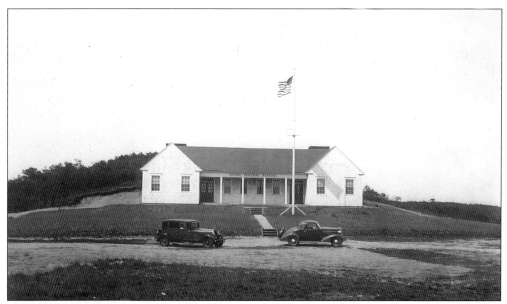

In 1851, a committee appointed to study public education in Truro recommended that the town be divided into districts, with schoolhouses in each district. Children attended the school closest to them, and the schools were often divided in two, with one room and a teacher for primary grades one through five, and the other room with another teacher, for grammar grades five through nine. In 1936, one school was built to consolidate all the grades, and Truro Central School opened, with 81 students attending. (Courtesy Dolores Rose.)

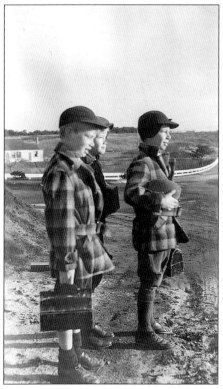

Lunch boxes and football in hand, three children wait for the school bus on a blustery morning c. 1937.

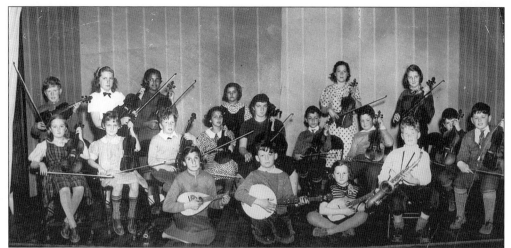

The Truro Central School band members shown in this *c.* 1938 photograph are, from left to right, as follows: (front row) Helen Silva, Edward Williams, Gloria Silva, and Christopher Worthington; (middle row) Elizabeth Dyer, Janet McClure, John Worthington, Marion Forrest, Dolores Mooney, Robert Dutra, Edward Perry, John Fratus, and Frederick Francis; (third row) George Rose, Shirley Viera, Marylou DeLuze, Bernice Dutra, Shirley Davis, and Josephine Morris. (Courtesy Truro Historical Museum.)

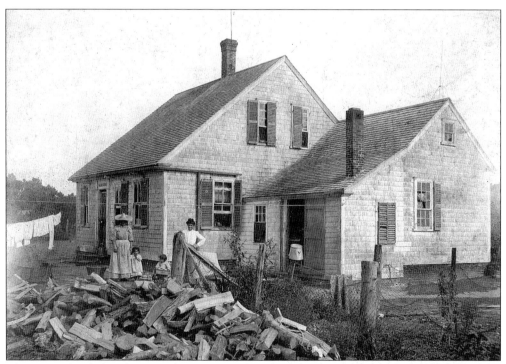

The Fratus family lived on South Pamet Road in this house. In 1930, the house burned to the ground from a fire caused by a spark from the chimney. This devastating fire and others in Truro were the motivations for the formation of fire and ambulance service in the town. (Courtesy Ann Kelley.)

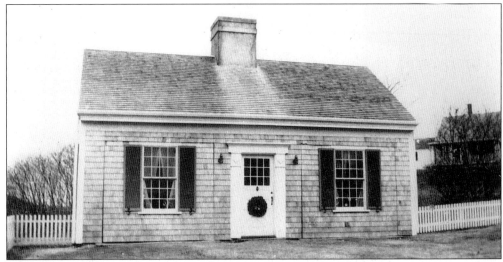

Truro had a unique firehouse that was built in 1938. From the outside, the building looked like a traditional Cape Cod–style house. Large panels on either side of the window were cut into the walls of the building. The panels lifted to reveal the storage bays for the ambulance and fire truck. (Courtesy Elizabeth Haskell.)

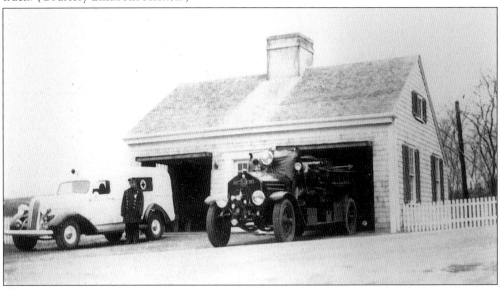

Ambulance driver Joseph Peters Jr. served as principal of Truro Central School from 1924 to 1964. (Courtesy Joe Peters.)

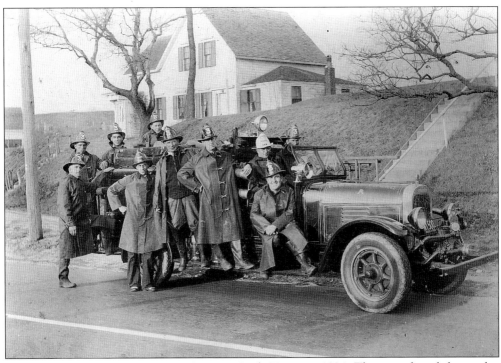

Volunteer firemen pose in Grozier Square, North Truro, in 1934. They are, from left to right, as follows: (front row) Edgar Francis, Harold Berrio, John Dutra, George Williams, George Dutra (wearing white hat), Dick Brown (seated on running board), and John Dutra Sr.; (back row) Joe Noons, Jack Noons, and Stanley Pierce. (Courtesy Marjorie Corea.)

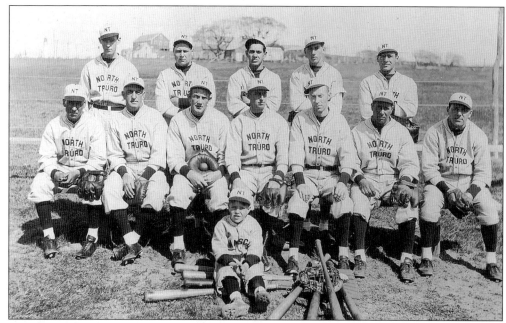

The 1931 North Truro baseball team includes, from left to right, the following: (front row) Edgar Francis Jr.; (middle row) Antone Silva, Edgar Francis Sr., Bill Gill, Ralph Tinkham, Tom Smith, John E. Dutra, and Joe Cabral; (back row) George C. Williams, John Thomas, Tony Duarte, Jimmy Morris, and Tony Lopes. (Courtesy Truro Historical Museum.)

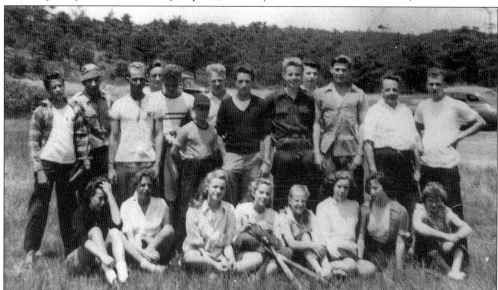

The Old Men versus the Young Men softball games started in the 1930s and continued for decades. Every Sunday during the summer, the games were held in various locations around town before moving to Snow's field by the town hall in 1948. From left to right are the following: (front row) Sally Carlton, Cindy Green, Patty May, Nan Keezer, Berthe Keezer, Allie Nelson, Jackie Abbott, and Mary Bunker; (back row) John Worthington, John Worthington Jr., Gordon Pirnie, Christopher Worthington, Neil Pirnie, George Glover, David Kerr, Ralph Woodward, and Don May.

Daniel Knowles MacFayden was born in Truro on June 10, 1905. He played baseball in high school. He went on to play in the Major League, from 1926 to 1943. He was a pitcher for the Boston Braves and the New York Yankees. After retiring from baseball, he became the athletic coach at Bowdoin College. He died in 1972.

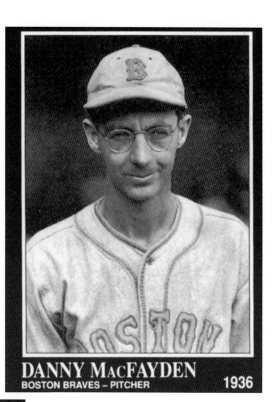

DANNY MacFAYDEN
BOSTON BRAVES – PITCHER
1936

DANNY MacFAYDEN 215

Daniel Knowles "Deacon Danny" MacFayden
Height: 5'11" Weight: 170 Bats: Right Throws: Right
Born: June 10, 1905, N. Truro, MA
Died: Aug. 26, 1972, Brunswick, ME

YEAR	TEAM	G	IP	CG	H	SO	BB	W	L	ERA
1926	Bos-A	3	13	1	10	1	7	0	1	4.85
1927	Bos-A	34	160	6	176	42	59	5	8	4.27
1928	Bos-A	33	195	9	215	61	78	9	15	4.75
1929	Bos-A	32	221	14	225	61	81	10	18	3.62
1930	Bos-A	36	269	18	293	76	93	11	14	4.22
1931	Bos-A	35	231	17	263	74	79	16	12	4.01
1932	Bos-A	12	78	6	91	29	33	1	10	5.08
1932	NY-A	17	121	9	137	33	37	7	5	3.94
1933	NY-A	25	90	2	120	28	37	3	2	5.90
1934	NY-A	22	96	4	110	41	31	4	3	4.50
1935	Cin-N	7	36	1	39	13	13	1	2	4.75
1935	Bos-N	28	152	7	200	46	34	5	13	5.09
1936	Bos-N	37	267	21	268	86	66	17	13	2.87
1937	Bos-N	32	246	16	250	70	60	14	14	2.93
1938	Bos-N	29	220	19	208	58	64	14	9	2.95
1939	Bos-N	33	192	8	221	46	59	8	14	3.89
1940	Pit-N	35	91	0	112	24	27	5	4	3.56
1941	Was-A	5	7	0	12	3	5	0	1	10.29
1943	Bos-N	10	21	0	31	5	9	2	1	6.00
TOTAL		465	2706	158	2981	797	872	132	159	3.96

Danny MacFayden pitched 17 seasons, losing more games than he won. He had 3 strong seasons with the Boston Braves from 1936–1938, compiling ERAs of 2.87, 2.93, and 2.95.

The Sporting News ®
CONLON COLLECTION®

Laura Ramsey Johnson—who with her husband, Jack, started the *Cape Codder* newspaper in 1946—wrote this poem about Truro: "Down in the Valley the meadow larks are singing / Up on the hills the distant bells are ringing / This is Truro's song / Over in the Pamet red wings are flying / Out in the orchard the West wind is sighing / This is Truro's song / Late in the twilight the shad bush is blowing / Under its boughs the heather is glowing / This is Truro's song / Now it is nightfall, fair Venus is beaming / In her great light, the ocean is gleaming / All this is Truro's song." (Courtesy Dolores Rose.)

Three

LANDMARKS AND THE SEA

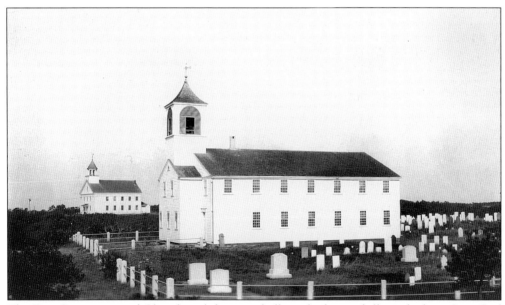

The First Congregational Church and the town hall rest high on a hill overlooking Cape Cod Bay. Truro resident Solomon Davis built the First Congregational Church in 1827. It has a bell cast from the Revere foundry. Pews were sold to individuals as a way to help with construction cost. Union Hall, built in 1848 adjacent to the church, was the first name for the town hall. First erected as a place for citizens to hold meetings and social activities, it was owned in shares by a group of Truro residents. It was not until 1870 that the town purchased the building for use as the town hall. It was used in the late 19th century as a shoemaking company and, later, as a hat-manufacturing company. (Courtesy Dolores Rose.)

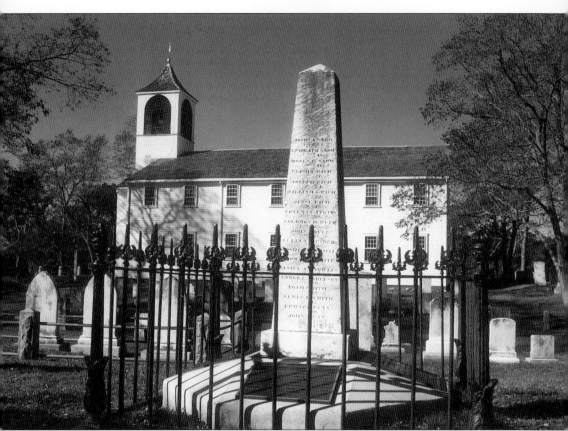

An obelisk in the graveyard of the Congregational church commemorates the worst disaster ever to befall Truro. Its inscription reads, "Sacred to the memory of fifty seven citizens of Truro who were lost in seven vessels, which foundered at sea in the memorable gale of October 3, 1941." The men left behind 27 widows and 51 fatherless children. The monument was dedicated in 1842, and each name is inscribed into the marble sides. The inscription continues, "Then shall the dust return to the earth as it was and the spirit shall return unto God who gave it. Man goeth to his long home and the mourners go about the street." (Courtesy Joyce Johnson.)

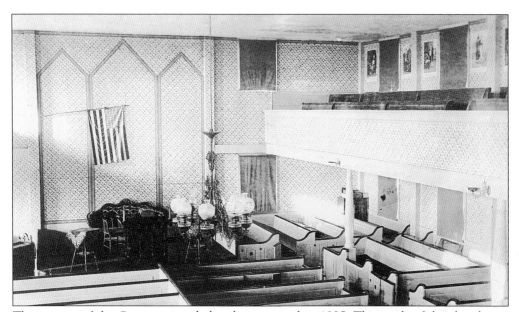

The interior of the Congregational church is pictured in 1925. The inside of the church was renovated in the 1940s, funded with proceeds from a memorable summer auction. The church has simple wooden pews and a modest design. (Courtesy Elizabeth Haskell.)

The South Truro Meeting House was built in 1851 to replace one that had grown too small for its congregation. Built high on a hill in South Truro, the meetinghouse was the center of a busy community. The population of Truro was at its highest in 1850, and as the population declined, so did the fortunes of the meetinghouse. By 1876, the congregation could not afford its own minister. (Courtesy Bill Cooper.)

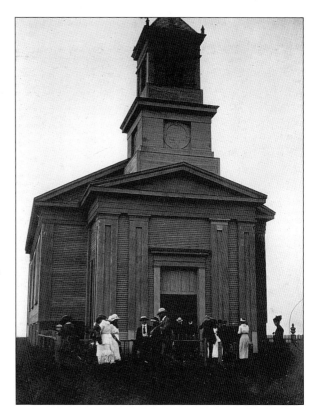

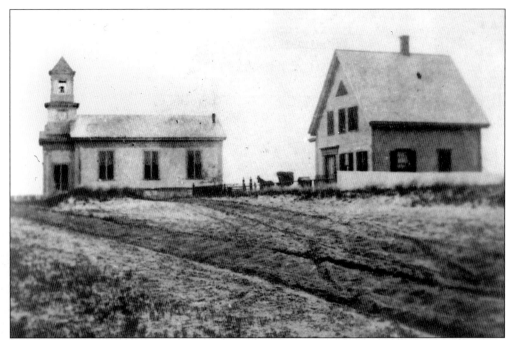

In 1880, the South Truro Meeting House was struck by lightning. Repairs were made to the church, but the economic decline of the congregation continued. In the late 1920s, the meetinghouse doors were closed and locked for good. The building stood empty and abandoned until it was struck by lightning on March 20, 1940, and burned to the ground. The parsonage, shown here next to the church, was blown off its foundation by a cyclone in 1905. (Courtesy Truro Historical Museum.)

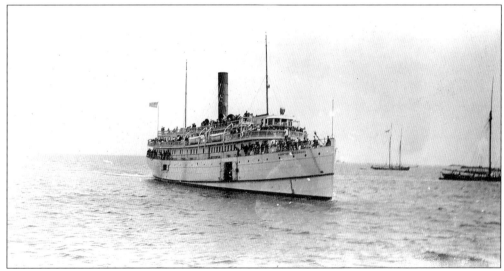

The 228-foot steamboat *Dorothy Bradford* was built in 1889. Owned by the Cape Cod Steamship Company, it made its maiden voyage between Boston and Provincetown in 1910. The steamboat was the major source of transportation between Boston and Provincetown (in addition to the railroad) and operated until the late 1930s. In 1931, a round-trip fare cost $2. (Courtesy Franklin Lewis.)

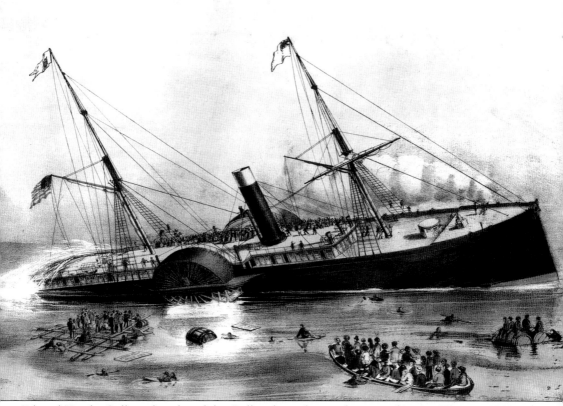

Edward Knight Collins, founder of the Collins line of steamships, was born in Truro in 1802. His ship, the *Arctic*, was considered one of the finest ships afloat. The *Arctic* sailed from Liverpool, England, on September 20, 1854. On September 27, 1854, it collided with a French ship, the *Vesta*, off Cape Race in Newfoundland. Most of the estimated 400 people on board were lost, including Collins's wife, son, and daughter. There were few survivors. A book entitled *Women and Children Last*, by Alexander Crosby Brown, depicts the fierce struggle on the *Arctic* as each person tried to save himself. (Courtesy Truro Historical Museum.)

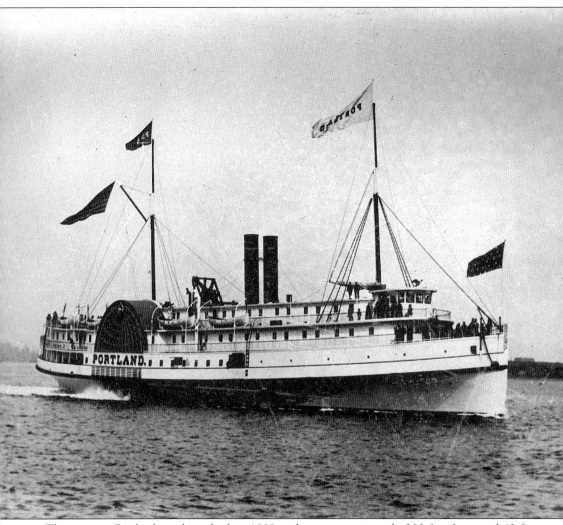

The steamer *Portland* was launched in 1889 and was approximately 280 feet long and 42 feet wide. It could accommodate 800 passengers. On Saturday, November 26, 1898, at 7 p.m., the *Portland* left India Wharf in Boston for Maine. Unbeknownst to Capt. Hollis Blanchard and crew, a monstrous storm was sweeping up the coast, and the *Portland* never reached her destination. On Sunday, a surfman from the Peaked Hills Life Saving Station found a life belt with the name *Portland* inscribed on it. Large amounts of debris began to wash up on the shore near the Race Point and Peaked Hills Life Saving Stations. Then, bodies began to wash ashore. By Tuesday, the rest of the world was alerted to the loss of the *Portland*, with all passengers and crew aboard. The Truro Historical Museum holds several items from the *Portland*, including chairs and drinking glasses. (Courtesy Truro Historical Museum.)

Sea captain Benjamin Dyer was born in Truro on October 25, 1793, and died on January 26, 1871. He was at sea during the heyday of the fishing and whaling industries in Truro. He was also one of the founders of Truro Academy. According to a 1909 historical address by John B. Dyer, 15 ships were built in Pamet Harbor between 1845 and 1853. Between 1840 and 1865, there were 111 ships under the command of Truro captains and manned by Truro crews. (Courtesy Truro Historical Museum.)

Matthias Rich, captain of the ship *Water Witch*, was one of the few to bring his vessel safely home in the gale of 1841. Born in Truro in 1820, Rich went to sea at age 11. At the age of 21, he was master of the *Water Witch* and, during the storm, was just able to navigate his vessel to the shelter of Herring Cove. He lashed himself to the helm at 6:30 on the morning of the storm and left the helm 12 hours later. Seven other vessels from Truro did not make it home. (Courtesy Truro Historical Museum.)

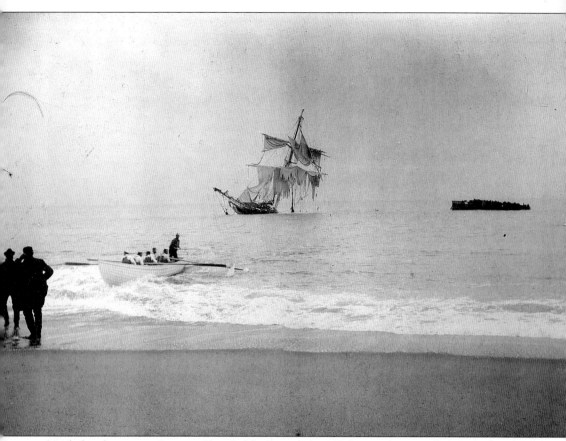

Loaded with a cargo of jute and headed for Boston from Calcutta, the British ship *Jason* wrecked off Truro's shore on December 5, 1893. It was under the command of a Captain McMillan, with a crew of 27. The foundering ship was visible to the surfmen at the Pamet River Life Saving Station, and they rushed to the scene. Under the command of Capt. John Harrington Rich, the lifesavers tried in vain to reach the stricken vessel. (Courtesy Truro Historical Museum.)

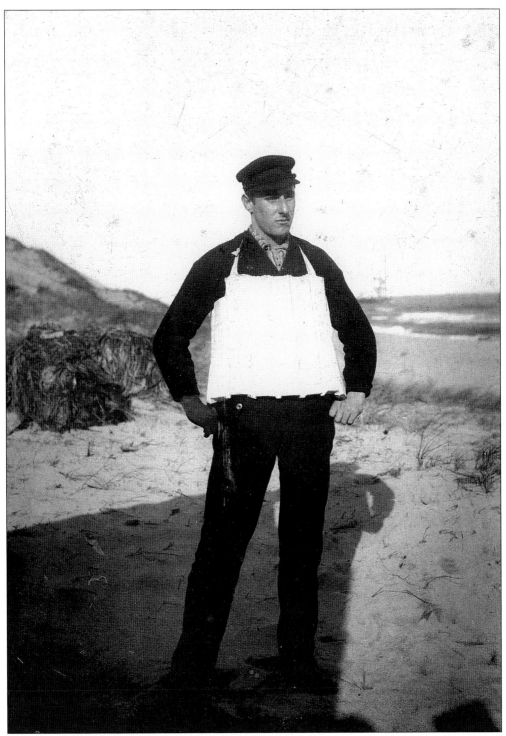

Clinging to a bale of jute, one person was pulled out of the sea—18-year-old Samuel Evans. All of the other 26 hands on board were lost. Evans recuperated in Truro and returned to England to sail again, only to lose his life from injuries suffered at sea. (Courtesy Truro Historical Museum.)

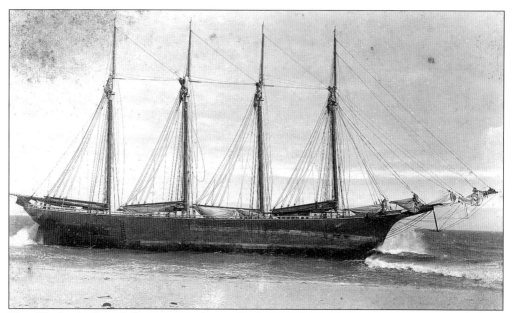

The *Charles A. Campbell* ran aground near the Pamet River Life Saving Station on March 14, 1895. The 1,576-ton schooner was stranded for two days before being freed and towed to Provincetown Harbor. In 1912, the *Charles A. Campbell* once again ran aground, this time in Wellfleet. (Courtesy Elizabeth Haskell.)

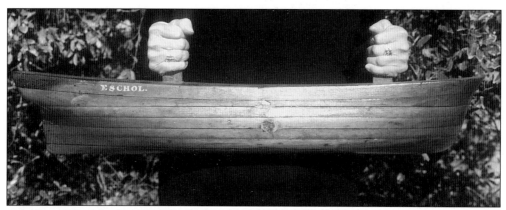

A half model of the brig *Eschol* was found in Truro many years ago and is part of the Truro Historical Museum collection. This three-dimensional model was carved to scale and represented the design of the ship. The horizontal sections, called lifts, were separated from the half model and scaled up to full size. (Courtesy Joyce Johnson.)

Nehemiah Rich was the captain of the *Eschol*, which was built in Pamet Harbor. (Courtesy Daniel Sanders.)

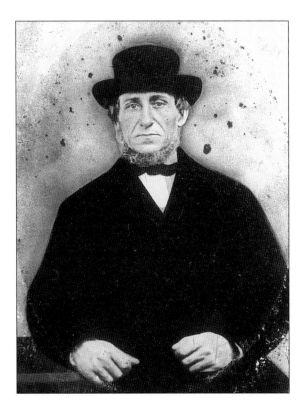

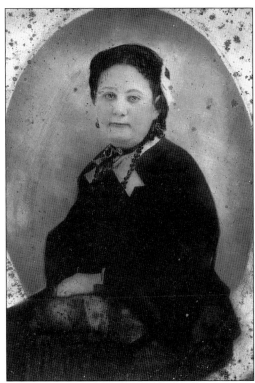

Hope Cobb Rich was the wife of Nehemiah Rich. (Courtesy Daniel Sanders.)

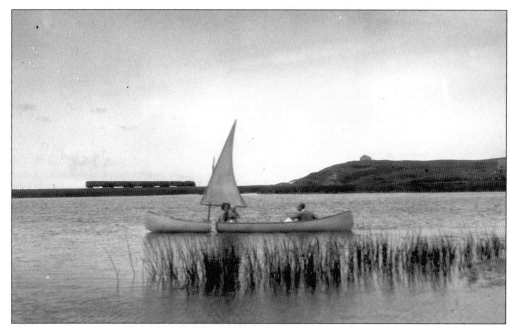

This couple and their baby are enjoying high tide in the Pamet River in their sailing canoe c. 1928. The mouth of Pamet Harbor has shifted over the years due to the constant silting by strong currents and winds. It was the filling up of the harbor that was largely responsible for the demise of the fishing and whaling industries from Pamet Harbor.

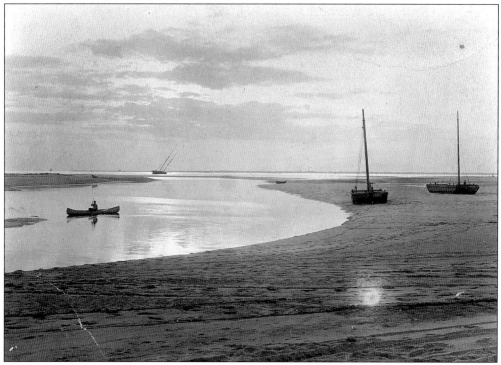

The channel in Pamet Harbor in 1913 was not deep enough for large ships to navigate safely. The bargelike boats on the sand flats were scows used to drive poles for trap fishing.

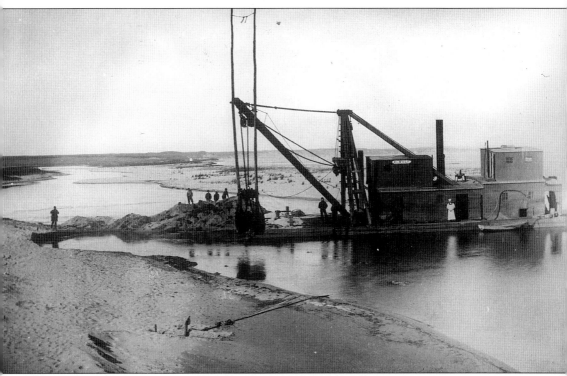

There have been many designs for new channels for the harbor. In 1919, two jetties were built at the mouth and a new channel was dredged. In 1965, the channel had filled in and was dredged again. The dredging of the harbor continues to be a concern for the town. (Courtesy Cape Cod Photos.)

East Harbor, shown here c. 1870, was one of the main harbors in Truro and, during the 1800s, was fully navigable. When the hills of Truro were stripped of trees, the sand dunes began to shift and East Harbor started to fill up with sand. In 1855 and 1858, attempts were made to slow the sand by building first a bridge and then a solid dike across the inlet. Construction of the railroad further contributed to closing the inlet, and East Harbor turned into Pilgrim Lake. (Courtesy Truro Historical Museum.)

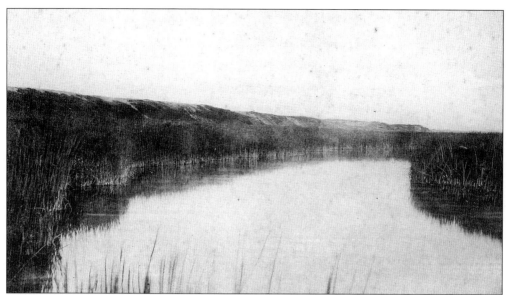

By the time of this photograph, East Harbor was a much smaller brackish body of water called Pilgrim Lake. (Courtesy Cape Cod National Park Service.)

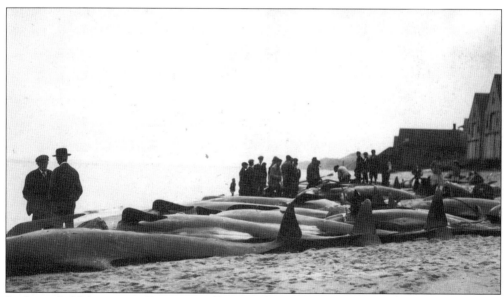

In the early 20th century, Truro was still engaged in whaling, particularly in the harvesting of oil from blackfin, otherwise known as pilot whales. When a school of blackfins was spotted, men stationed on shore would quickly sound the alert. Boats would go out and make as much noise as possible to disorient the whales and drive them onshore. (Courtesy Mildred Garran.)

Men harvest blubber from their catch of blackfins. (Courtesy Isaiah Snow.)

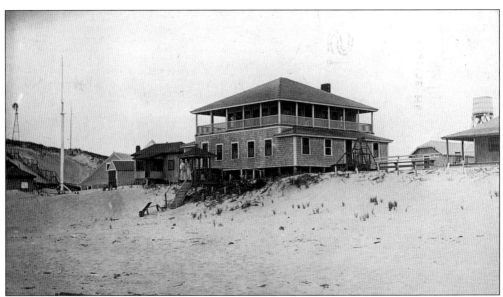

Ballston Beach is named after Sheldon W. Ball and his wife, Lucy, who purchased 1,000 acres of oceanfront land in Truro in 1889. They developed the area into a summer resort destination that was known as the Ballston Beach Colony. In addition to a central building, Ball built numerous cottages along the cliffs overlooking the ocean. The inn, shown here c. 1909, contained dining facilities and a dance room. (Courtesy Isaiah Snow.)

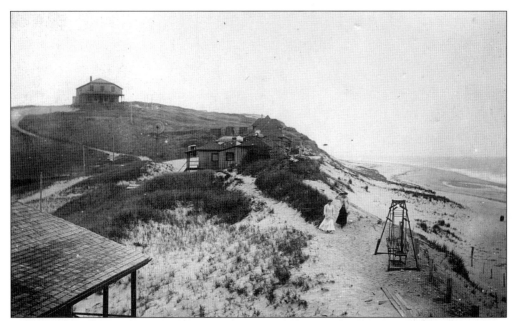

Ladies walk along the dunes of Ballston Beach *c*. 1909. The Ballston resort was well known for its recreational activities, such as dances, parties, and picnics. There was a bowling alley on the premises and a wooden swingset overlooking the ocean. (Courtesy Truro Historical Museum.)

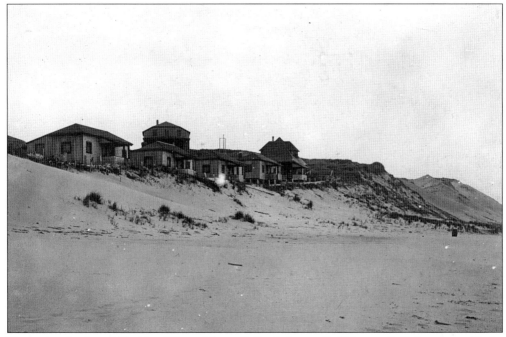

Upon the deaths of Sheldon W. and Lucy Ball, their son S. Osborne Ball, known as Ossie, inherited the property. The Cape Cod National Seashore took over the property after Ossie died, and the remaining cottages were torn down. (Courtesy Truro Historical Museum.)

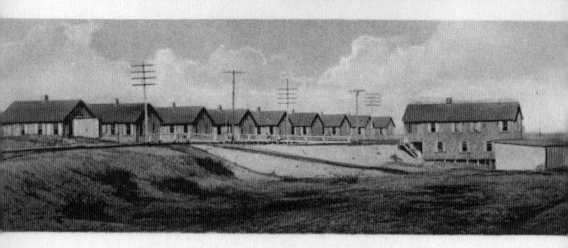

VIEW FROM STATE HIGHWAY

Each cottage has a screened porch on the water front; a living room with fireplace; two bed rooms; a kitch itted for cooking; and bath with toilet, lavatory and shower. Beds are fitted with Simmons springs and Simmo nationally advertised inner spring mattresses. Each living room has a cot, which if made into a bed will c $ 1.00 per week, or part thereof.

When Joseph A. Days purchased land along the shore of North Truro in 1910, the state highway was a dirt road. Near the beginning of the Great Depression, Days started to build summer cottages on his property. He initially began with five cottages, but the complex quickly grew when he purchased land on the other side of the road and continued to build. Before long,

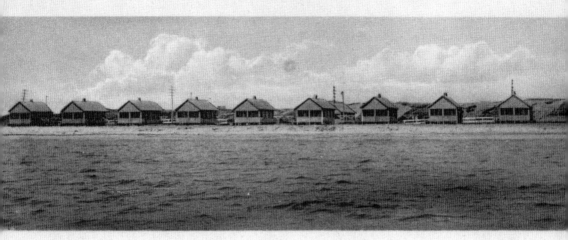

VIEW FROM WATER FRONT

These cottages are open from May 15th to October 15th.

Rates — $ 5.00 per night — $ 30.00 per week — $ 100.00 per month. Before May 25th and after Sept. 10th, rate$
$ 3.00 per night. A deposit of $ 5.00 will be required when engaging cottage; said deposit will hold cottage until 1
after engaging date, after which it will be forfeited by the depositor. All rentals expire at 1 P.M.
Linen, Silverware and electricity included in the above prices.

there was a rental office, a small grocery store, and nine cottages. Days Cottages and Self Service Market opened for business in the summer of 1931. Business grew throughout the 1930s, and so did the complex. By the end of the 1930s, there were 22 cottages—all of them named after a flower. Days Cottages has been in business ever since. (Courtesy Joseph Days.)

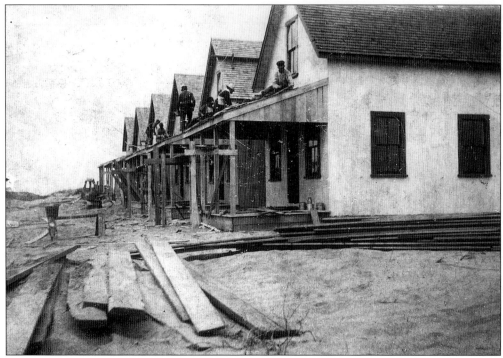

The Corn Hill cottages were built between 1898 and 1902 for Lorenzo D. Baker, president of United Fruit Company. Baker hired Charles W. Snow and his crew to construct summer cottages along the bluff on Corn Hill, seen here in 1902. (Courtesy Truro Historical Museum.)

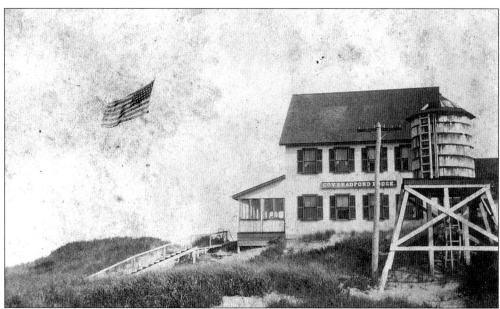

The Governor Bradford Lodge, part of the cottage complex, was the reception area and dining room. The tower adjacent to the building supplied water. (Courtesy Truro Historical Museum.)

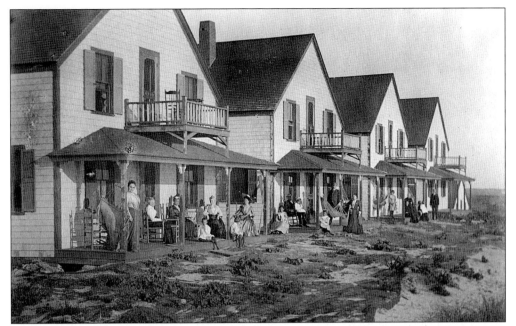

The picturesque cottages soon overflowed with summer visitors. The location of the cottages on the edge of the bluff overlooking Cape Cod Bay offered breathtaking views, and a series of wooden steps led down to the beach. (Courtesy Sandra Gilley.)

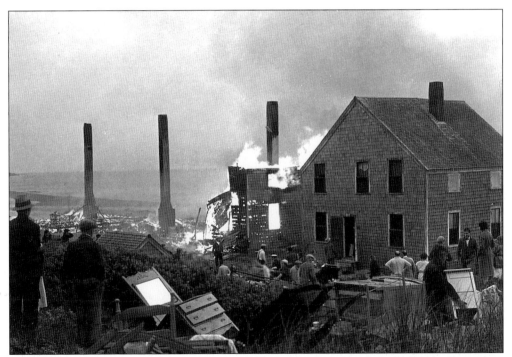

On July 4, 1933, an entire row of the cottages burned to the ground. Only the chimneys were left standing after the disaster. In this photograph, townspeople watch helplessly as the last of the cottages burns. (Courtesy Truro Historical Museum.)

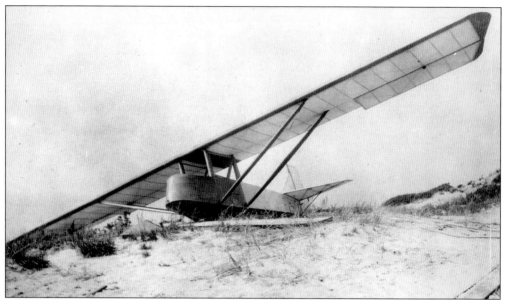

In the summer of 1928, Peter Hasselbach of Darmstadt, Germany, set off from Corn Hill in his glider and remained aloft for 4 hours and 5 minutes. On one of his previous flights, Hasselbach had broken the Wright brothers' 1911 record (9 minutes and 45 seconds) by remaining in the air for 55 minutes. (Courtesy Truro Historical Museum.)

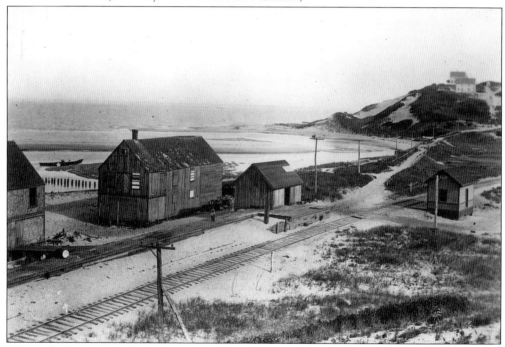

This view, looking north toward Corn Hill *c.* 1910, shows the proximity of fish houses and the railroad to the shore. Fish houses were utilitarian structures built along the beach for fishermen to mend their nets, store their gear, and wait for the next favorable tide. Right alongside the fish houses ran the railroad, which had a station at Corn Hill and another station a half mile south at the Truro depot.

In the late 19th century, the Underwood Company owned a fish cannery on the beach in North Truro. The cannery produced pickled baby mackerel, whiting, and perch. The cannery was located in one of the fish houses foremost on the right, and Edward Morgan was manager. (Courtesy Mildred Garran.)

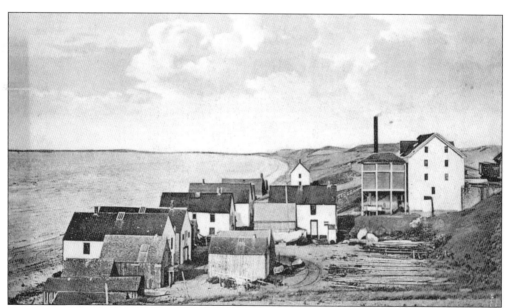

The North Truro Cold Storage Company is the large building on the right, between the fish houses and the railroad tracks. The long poles on the right were to secure the net of the fish weirs. (Courtesy Mildred Garran.)

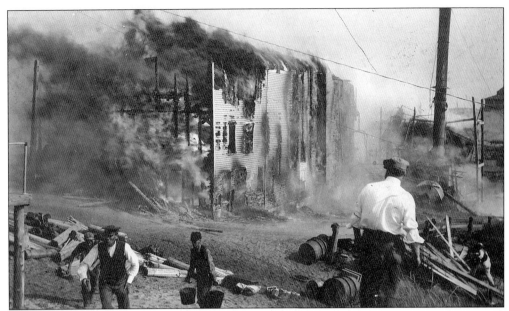

On Labor Day 1914, the North Truro Cold Storage Company plant burned to the ground. People tried valiantly to quench the fire with buckets of water. The entire plant was rebuilt within a year. (Courtesy Mildred Garran.)

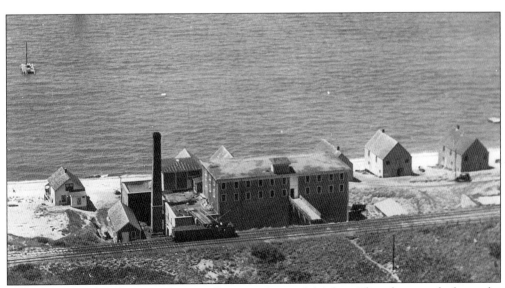

The new plant was a larger and more efficient version of the first. This photograph shows the loading ramp for moving fish and supplies between the plant and the railroad.

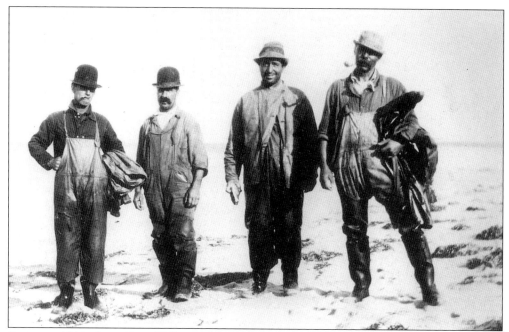

Posing c. 1910, these Corn Hill trap fishermen are, from left to right, Joe Davis, Capt. Tony Joseph, John Gray, and Manuel Marshall.

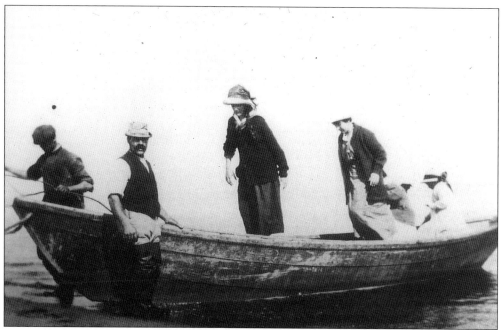

Capt. Tony Joseph aids the ladies disembarking at Corn Hill c. 1910. The congenial fishermen often ferried passengers to shore from Provincetown.

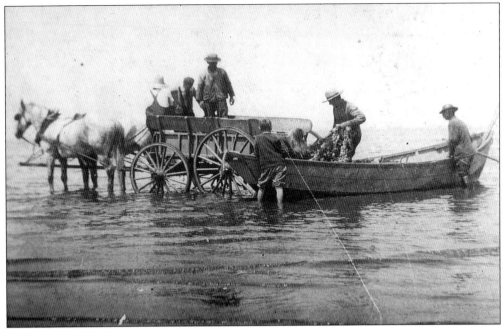

Trap fishermen load nets onto a horse-drawn wagon c. 1910. The nets were dipped in tar to help withstand the effects of saltwater. They often needed repair or retarring, and all of the work was done by hand.

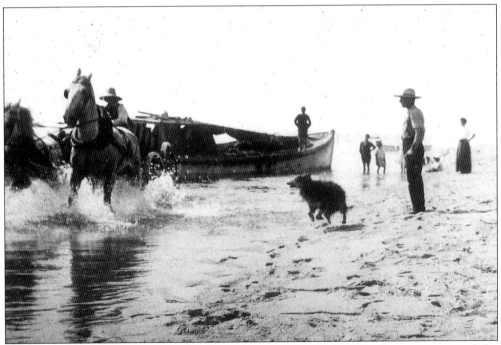

There was a business arrangement between the owner of the horse-and-wagon team and the fishermen. Each day, the same team would meet the boats and unload the gear and the catch. In this view, the horses labor to pull the heavy catch to the shore.

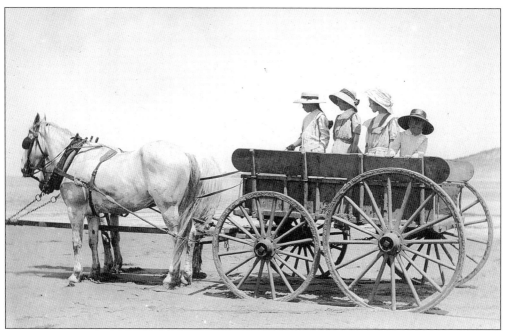

Dressed in their Sunday best *c*. 1910, these young girls are playing on the same wagon used by the fishermen.

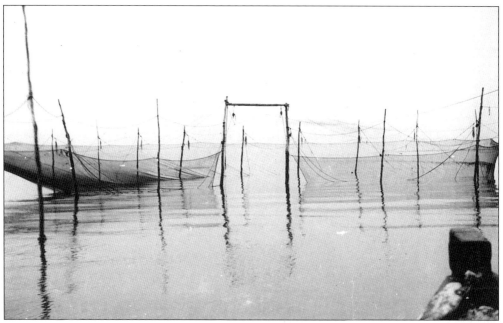

Trap fishing was practiced by Native Americans centuries ago, but the first traps, or fish weirs, were set in Truro in the 1870s. Long poles made of hickory set in the sand held the nets. The hickory poles were used because they tended to be straight and resistant to rot. (Courtesy Truro Historical Museum.)

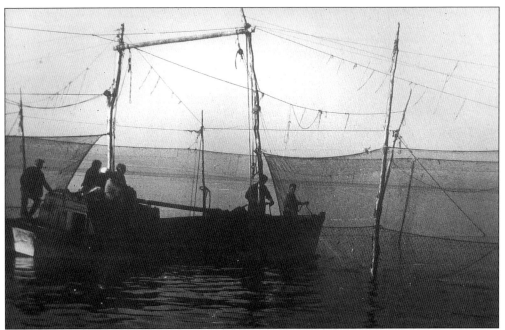

Going into the traps meant navigating the poles and nets—not an easy task. Up to five men worked on a trap boat, and it took about a week to set a trap, provided the weather was good.

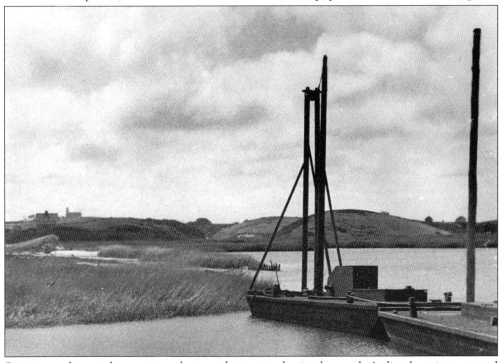

Scows were barges that were used to set the weir poles in the sand. A diesel engine pumped water through a hose that had a nozzle attached to the end. The nozzle was attached to the bottom of the pole. As the forced water drove a hole in the sand, the end of the pole was seated in it, to a depth of about five feet. The poles were more than 40 feet long.

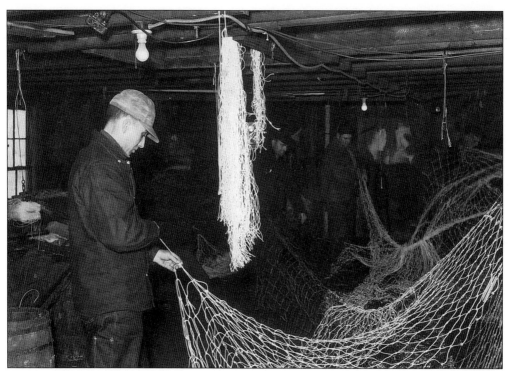

John L. "Shiney" Silva is mending twine in one of the fish houses on the beach c. 1940. (Courtesy Truro Historical Museum.)

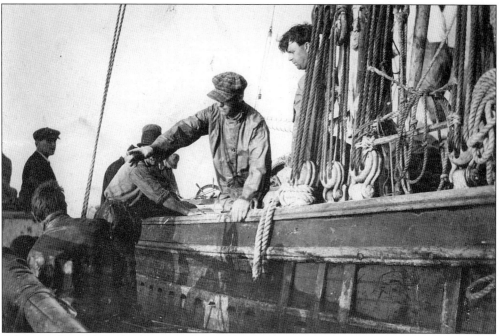

Schooners headed for the Great Banks would signal to the trap fishermen that they needed bait by flying an American flag upside down. The trap fishermen would meet them in deep water and hand over the bait. Here, fishermen are trading. (Courtesy Anna Duart.)

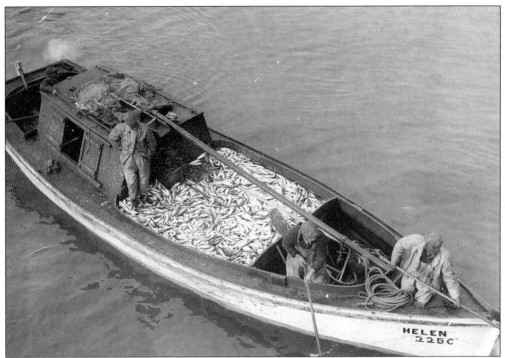

The *Helen*, a typical trap boat, is shown returning with a catch in the mid-1930s. All kinds of fish were caught in the nets, including mackerel, herring, whiting, hake, and fluke. The traps were emptied as often as six times a day.

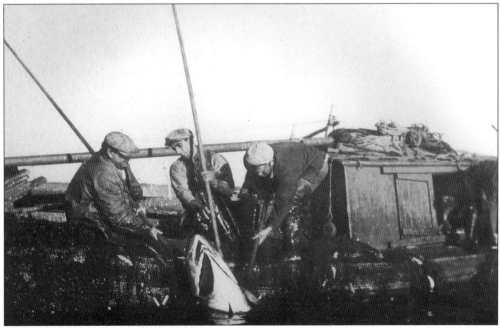

Sometimes, larger fish, such as shark and tuna, were caught in the nets, gaffed, and brought aboard. Fresh fish were packed in ice in the days before refrigeration and were shipped on ice to the fish markets by train.

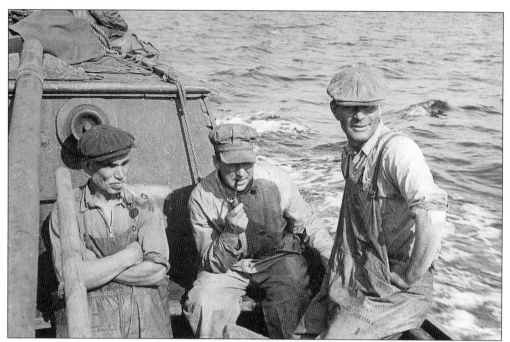

Pictured *c.* 1940, these trap fishermen are, from left to right, Joaquine "Joe King" Noons, Antone "Caruso" Silva, and Frank "Alley" Rose. (Courtesy Truro Historical Museum.)

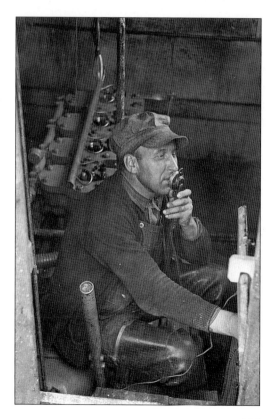

Using a hand-held microphone, Antone Silva calls to the deck of a trap boat from below *c.* 1940.

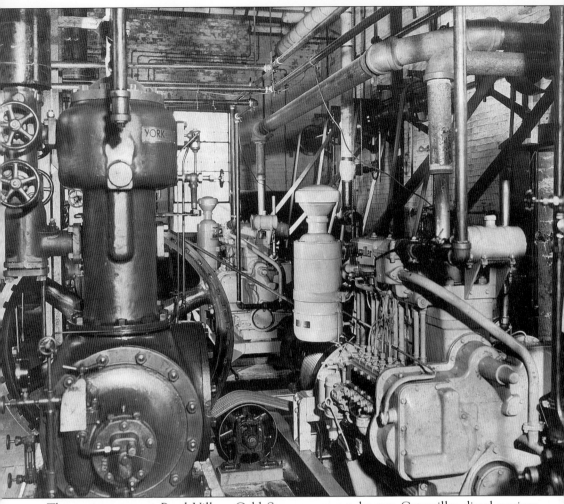

The engine room at Pond Village Cold Storage was run by two Caterpillar diesel engines, driving York compressors, and had two 250-gallon-per-minute water pumps and two 300-gallon-per-minute brine pumps. Each engine operated 24 hours a day on four gallons of fuel, which (at the time of this July 1938 photograph) cost the company 5.6¢ fuel per hour. The engine room provided freezing and cold storage facilities for the many tons of fish caught by the company. Pond Village Cold Storage operated from the 1930s until the late 1960s, when there was no longer surplus fish to freeze.

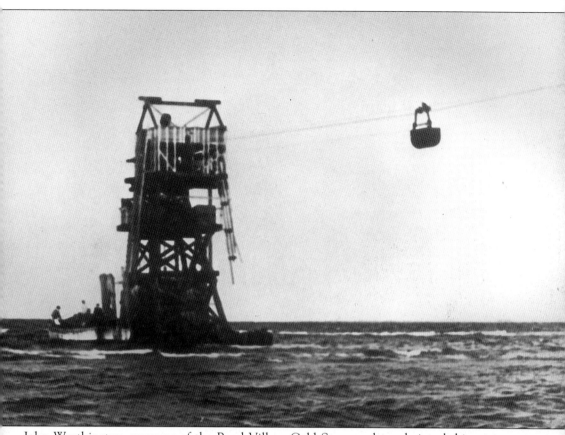

John Worthington, manager of the Pond Village Cold Storage plant, designed this tower to eliminate the task of unloading fish on the shore at the Provincetown wharf and trucking it to Truro. The tower was built 100 yards offshore. The bucket, or hopper, ran via cable from the tower to the third floor of the cold storage plant. Vessels could unload 1,000 pounds of fish every few minutes this way. The process could also be reversed, and frozen slabs of bait fish could be picked up at the tower by schooners headed out to sea. The tower was torn down in 1999.

The train would stop a couple of times a day at the cold storage plant, and frozen fish were shipped as far as Chicago. Railroad men would often stop at the freezer and ask for mackerel for themselves.

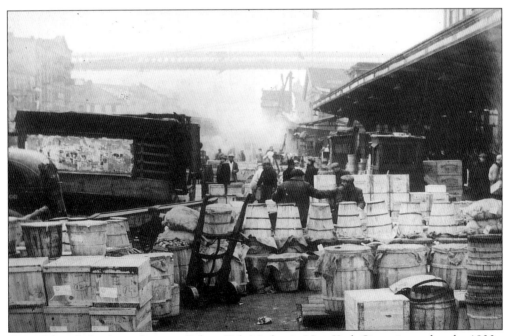

One of the wholesale markets was Fulton Fish Market in New York City, pictured *c.* the 1930s. The fish would arrive there within 24 hours after leaving Truro.

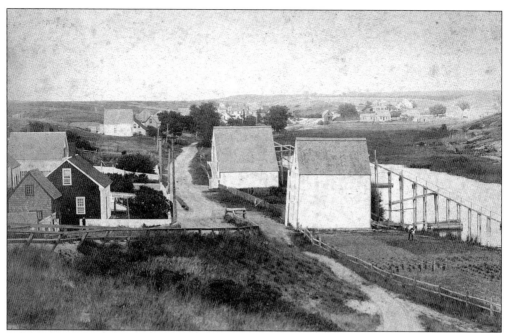

Before there was refrigeration, icehouses provided the means for preserving the fish until it reached consumers. Chunks of ice were cut from the pond, mixed with salt, and stored in layers of hay. The fish was packed with the ice to prevent it from spoiling. There were two icehouses in North Truro, overlooking Pilgrim Pond. (Courtesy Truro Historical Museum.)

Antone Duarte, shown here with his family, was the owner of the icehouses. From left to right are Wilhemena, Tony, Edie, Antone, Mary, Joe, and Angelina Duarte. (Courtesy Toni Marsh.)

In the early 1930s, Ada "Tiny" Worthington began to experiment with fishnet to make curtains for her home. Out of that experiment grew a cottage business called Cape Cod Fishnet Industries. Worthington designed home and fashion accessories from fishnet and started her business in the second floor loft of a fish house. Fishermen's wives, working from their homes, sewed the designs.

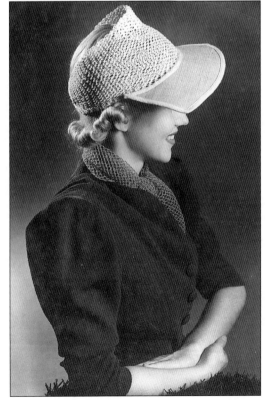

Worthington first dyed the net on the beach, using the sea as mordant and drying the nets on the sand. She experimented with colors, trying to capture the subtle beauty of the hues from the hills and the sea. Her fashions were sold throughout the country, and the Duchess of Kent was photographed wearing one of her fishnet turbans in 1936.

The business outgrew the fish house, and Worthington moved it to the old North Truro Grammar School in Grozier Square. The business prospered for years, selling accessories wholesale and with her retail operation.

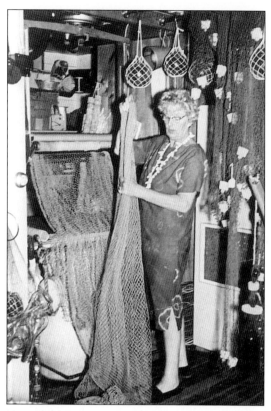

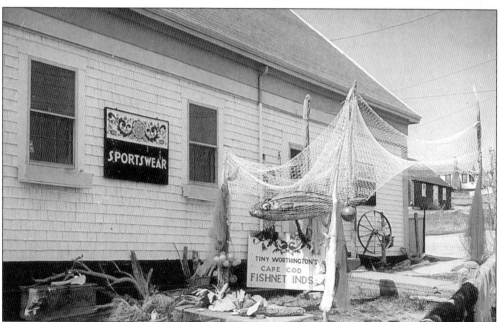

Adapting to the change in demand for fishnet clothing, Worthington concentrated on gift items with a Cape Cod motif, such as driftwood, buoys, glass floats, and seashells. Generations of tourists have made an annual stop at her store.

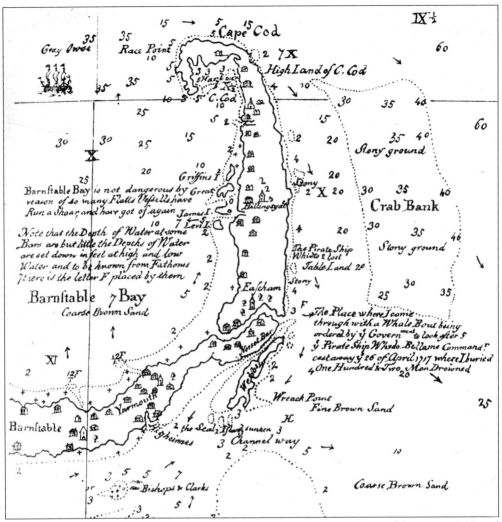

This old map of Truro and Provincetown is thought to have been created between 1715 and 1720. The U.S. Coast and Geodetic Survey republished it in 1891. Note the mention of the pirate ship *Whidah* under the "Bellame Command," where "I buried One Hundred and Two man Drowned." Bellame was referring to the pirate captain Samuel Bellamy. The wreck of the *Whidah* was discovered in the 1980s. (Courtesy Cape Cod National Park Service.)

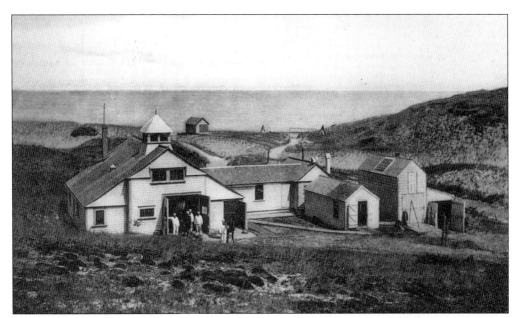

The Highland Life Saving Station was one of three lifesaving stations built in Truro between 1872 and 1896. The stations were manned from August until June, except for the station keeper, who was on duty year-round. Capt. Edwin Worthen was the keeper at Highland for 30 years. In the early years of lifesaving, the keepers were paid $200 annually, but surfmen earned $40 per month.

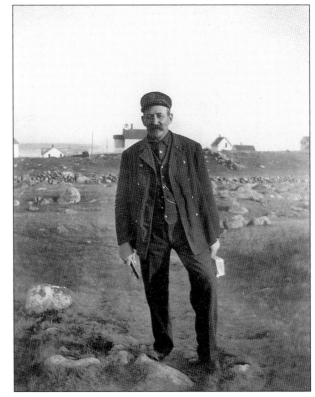

Hiram R. Hatch was the No. 2 surfman at the Highland Life Saving Station. Born in Truro, he went to sea until he was 23 years old, at which time he joined the station. The surfmen were assigned numbers according to merit, with No. 1 being the position most trusted and competent. (Courtesy Truro Historical Museum.)

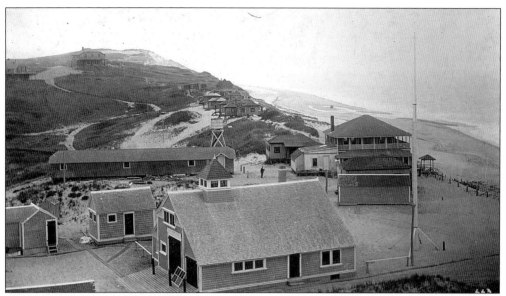

The Pamet River Life Saving Station, shown here in 1909, was built in 1872 near the Ballston Beach summer colony. It was from this station that the men tried to save the crew of the *Jason* in 1893. (Courtesy Truro Historical Museum.)

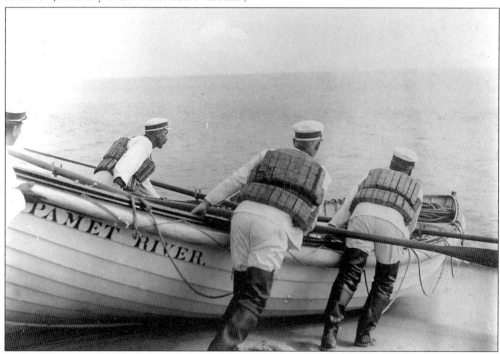

The crew of the Pamet River station launches a surf boat in 1908. Practice drills were held constantly, and each man had specific tasks outlined in their service manuals. The men practiced launching and landing, capsizing and righting the boat, and the use of oars. On land, they practiced rescuing people with a piece of equipment known as a breeches buoy. The breeches buoy was used when vessels wrecked near shore and could be reached from land with the equipment. (Courtesy James Whitelaw.)

Capt. George W. Bowley (left) and Ephraim S. Dyer are shown at the Pamet River Life Saving Station in 1902. Bowley was born in Provincetown and was keeper of the station. Dyer, born in Truro in 1845, was the No. 1 surfman at the station. (Courtesy Cape Cod National Park Service.)

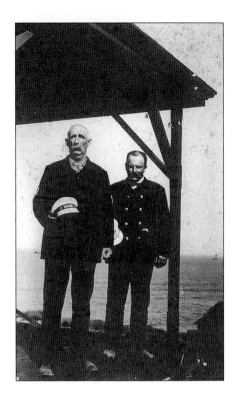

Stephen Snow Lewis was appointed first assistant keeper of Highland Light on November 29, 1875. In 1882, he became keeper of the Nauset Lighthouse, a position he held until 1914. He died in 1926 at age 90 in his ancestral home in North Truro. (Courtesy Franklin Lewis.)

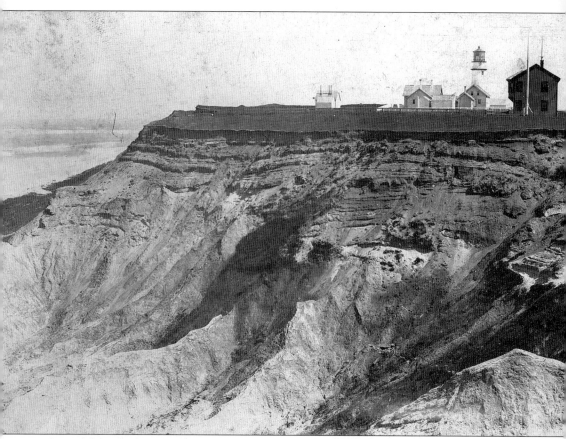

One of the most historic landmarks on Cape Cod is the Cape Cod Lighthouse, also known as Highland Light. In 1797, the government purchased 10 acres of land from Isaac Small for the purpose of erecting a lighthouse. The lighthouse was built on a bluff some 140 feet above sea level and about 510 feet from the edge. Small served as the first keeper of the lighthouse. The first lighthouse was rebuilt in 1853 and was replaced in 1857 with the structure that stands today. Erosion of the cliff at Highland Light has been a concern since Henry David Thoreau wrote about it after his visit in the mid-1800s. By 1988, the lighthouse was only 143 feet from the edge. By 1990, the distance had diminished to 128 feet. In a monumental effort to save the lighthouse in 1996, it was moved 453 feet back from the cliff. (Courtesy Truro Historical Museum.)

Isaac Morton Small and his wife, Lillian, are pictured c. 1910. Isaac, known as Mort, is credited with developing the Highland Light area as a resort destination. Born in 1845, he was the son of James Small and the grandson of Isaac Small. Isaac Morton Small grew up on the Highlands, on property adjacent to the lighthouse and part of his grandfather's prosperous farm. Upon the death of his father in 1874, Small added a guest wing to his farmhouse and shortly thereafter built a separate building called the Cliffhouse. One of the first people in Truro to recognize its appeal to tourists, he used the farmhouse for guests and the Cliffhouse as his residence. As demand for summer lodging increased, he continued to build cottages on his property. Small was keeper of the marine telegraph station adjacent to the lighthouse. He also wrote newspaper articles, kept accounts of shipwrecks, and served in municipal positions and then in the state legislature. He married twice and died in 1932. (Courtesy Truro Historical Museum.)

Henry David Thoreau was an early visitor to the Highland Light area. According to Isaac Morton Small, Thoreau first visited with his family in 1850 and then again in 1855. He stayed in the first Highland House, built in 1835 by the Isaac's father, James Small. The Highland

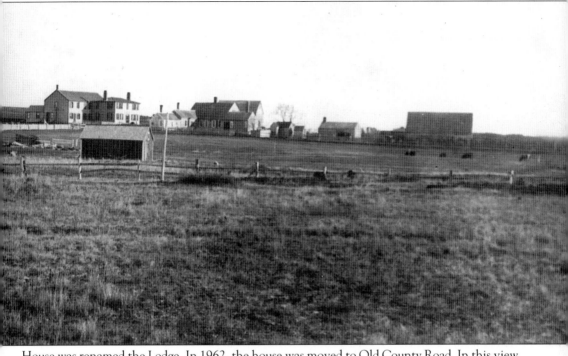

House was renamed the Lodge. In 1962, the house was moved to Old County Road. In this view of the Small farm, taken prior to 1892, the Highland Lodge is the large building to the right of the gristmill. The area was known for its fertile soil. (Courtesy Truro Historical Museum.)

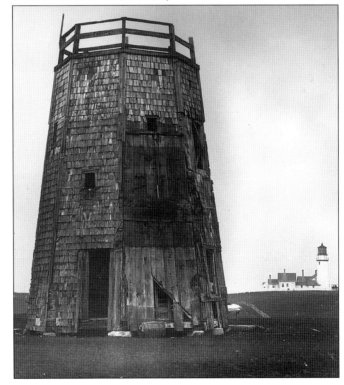

Isaac Small erected this windmill on his farmland in 1785 for the grinding of corn and other grains. His sons James and Joshua Small took over operation of the windmill after his death, and it was finally dismantled in 1892. (Courtesy Truro Historical Museum.)

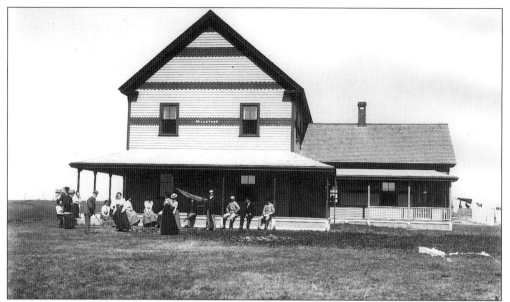

Millstone Cottage was built by Isaac Morton Small in 1898 on the site of his father's windmill. In this *c.* 1900 photograph, visitors on the front porch prepare for a round of golf. (Courtesy Truro Historical Museum.)

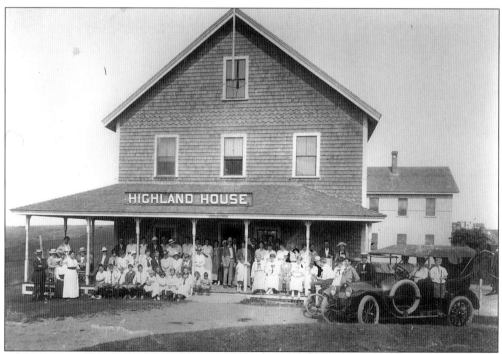

In 1907, Isaac Morton Small built the second Highland House, which operated as a restaurant and hotel until 1969. The building was located next to the Highland Golf Links and just west of Highland Light. Guests were ferried up to the area by the hotel carriage, which met them at the North Truro railway station. This property now houses the Truro Historical Museum. (Courtesy Truro Historical Museum.)

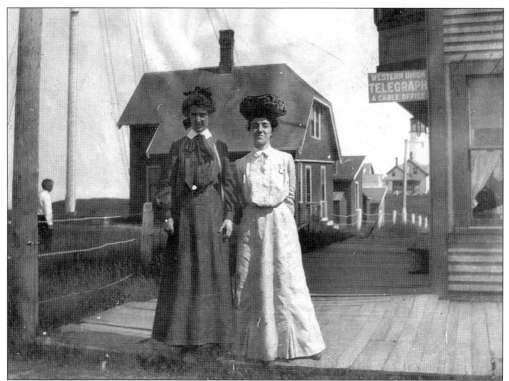

Grace Rich Burns (left) and Eve Cole Bold stand in front of the Cliffhouse at Highland Light c. 1919. (Courtesy Truro Historical Museum.)

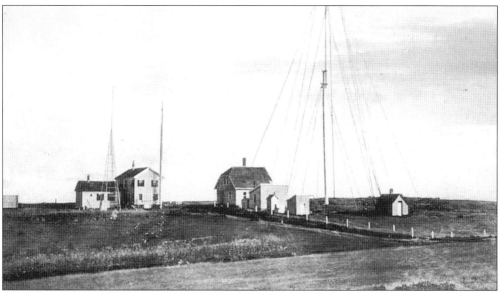

The marine telegraph line was completed through to Provincetown in 1855. Isaac Morton Small took charge of the station in 1863 and spent 70 years observing and reporting on ships passing Highland Light. (Courtesy Mildred Garran.)

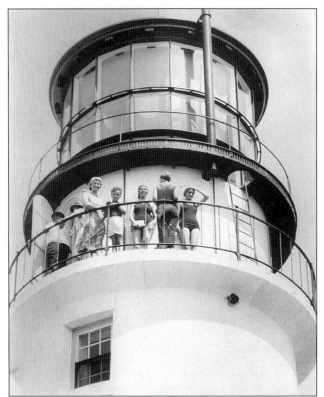

The lighthouse was first fueled by sperm oil. It later used lard, kerosene, and finally electricity. Highland Light was automated in 1987, when a new beacon with 1,000-watt bulbs was installed. The beacon was visible 20 miles away. In 1998, a more refined and smaller beacon was installed—visible 25 miles away. (Courtesy Peggy Galdston Frank.)

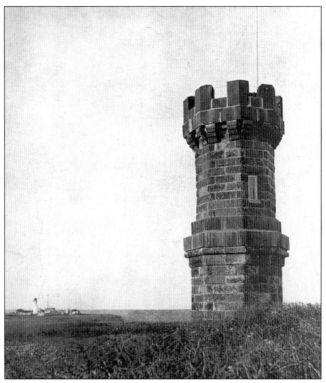

Henry Aldrich reassembled the Jenny Lind Tower in Truro in 1927. The turret was once part of the Fitchburg railway depot in Boston. According to one story, Swedish soprano Jenny Lind sang from the turret to calm a disappointed crowd when one of her concerts sold out. When the depot was demolished, Henry Aldrich purchased and moved it to Truro. (Courtesy Elizabeth Haskell.)

Ernest Hayes Small (1876–1939) was the younger brother of Isaac Morton Small's second wife. He took over management of the Highland House after the death of Small's son Willard in 1911. Ernest Hayes Small was also a farmer and served in the state legislature and in a variety of municipal positions. (Courtesy Truro Historical Museum.)

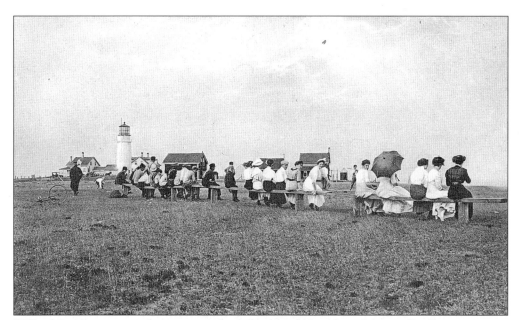

Willard Small was an avid sportsman who helped his father, Isaac Morton Small, in managing the Highland resort. Willard built a bowling alley near the Highland Golf Links. Tragically, he died at the age of 38 from a suspected heart attack during a ball game in 1911.

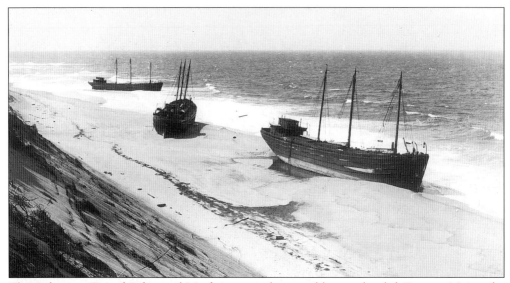

The *Coleraine, Tunnel Ridge,* and *Manheim* were three coal barges that left Bangor, Maine, for Philadelphia in April 1915. The barges encountered stormy weather and grounded off of Truro, near Highland Light. (Courtesy Edwina Wright.)

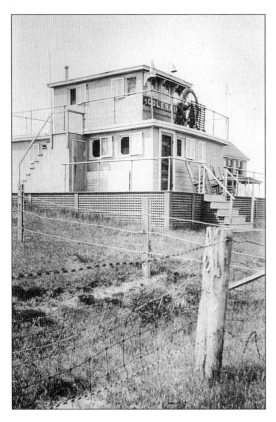

Rather than trying to refloat the *Coleraine,* Ernest Hayes Small had the deck house removed and hauled up the cliffs to Highland Light, where it became a three-room clubhouse for the Highland Golf Links. (Courtesy Franklin Lewis.)

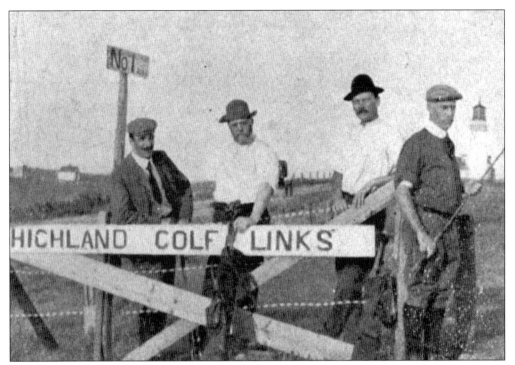

The Highland Golf Links were built in 1892 adjacent to the complex of guest cottages developed by Isaac Morton Small. The historic nine-hole golf course is known for its rough terrain and panoramic views. (Courtesy Cape Cod National Park Service.)

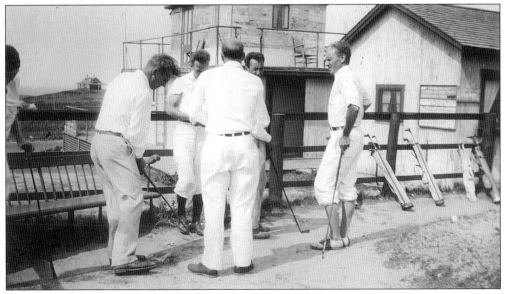

A foursome waits outside the clubhouse to tee off c. the 1920s. Two of the players are wearing "plus fours," a popular fashion in the 1920s.

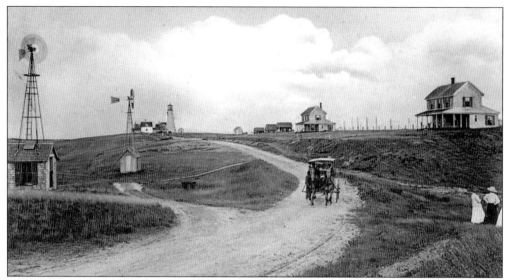

The horse and carriage is traveling the road to the golf links and lighthouse *c.* 1900. Windmills were a common source of energy. The lighthouse is visible in the distance. The cottages on the right were part of the Highland resort complex.

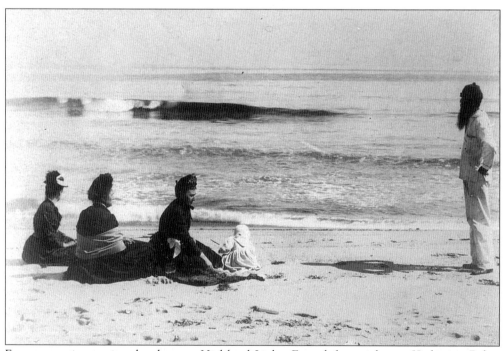

Four generations enjoy the shore at Highland Light. From left to right are Katherine Baker Lombard, Ruth Young Mayo Baker, Margaret Baker Lombard, baby Margaret Ellen Haass, and an unidentified surfman. (Courtesy Sandra Gilley.)

Agnes and Francis Mooney are pictured clamming on the sand flats in Truro. (Courtesy Dolores Rose.)

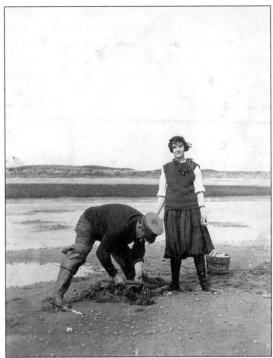

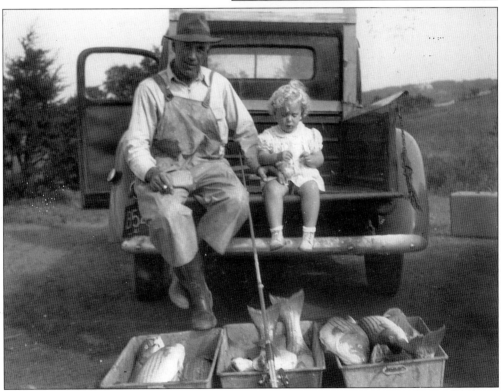

The lure of fishing is as strong today as when settlers first went to sea on vessels from Truro in the 18th century. In this *c.* 1941 image, a man poses with his daughter and a catch of bass.

BIBLIOGRAPHY

Commonwealth of Massachusetts. *Population and Resources of Cape Cod.* Boston: Wright and
 Potter Printing Company, 1922.
Dalton, J.W. *The Life Savers of Cape Cod.* Boston: the Barta Press, 1902.
Kane, Tom. *My Pamet Cape Cod Chronicle.* New York: Moyer Bell Limited, 1989.
Marshall, Anthony L. *Truro Cape Cod as I Knew It.* New York: Vantage Press, 1974.
Rich, Shebnah. *Truro: Cape Cod or Land Marks and Sea Marks.* Boston: D. Lothrop and
 Company, 1883.
Snow, Edward Rowe. *Storms and Shipwrecks of New England.* Boston: Yankee Publishing
 Company, 1943.
Thoreau, Henry David. *Cape Cod.* Boston: Houghton Mifflin Company, 1893.

Annie B. Young (center) and her son Lewis are pictured frolicking in the water with an unidentified friend *c.* 1904. The natural beauty of Truro—with sweeping panoramic views, miles of pristine beaches, and the lure of the sea—is as compelling today as it was a century ago. (Courtesy Suzanne Jaxtimer.)